D1536709

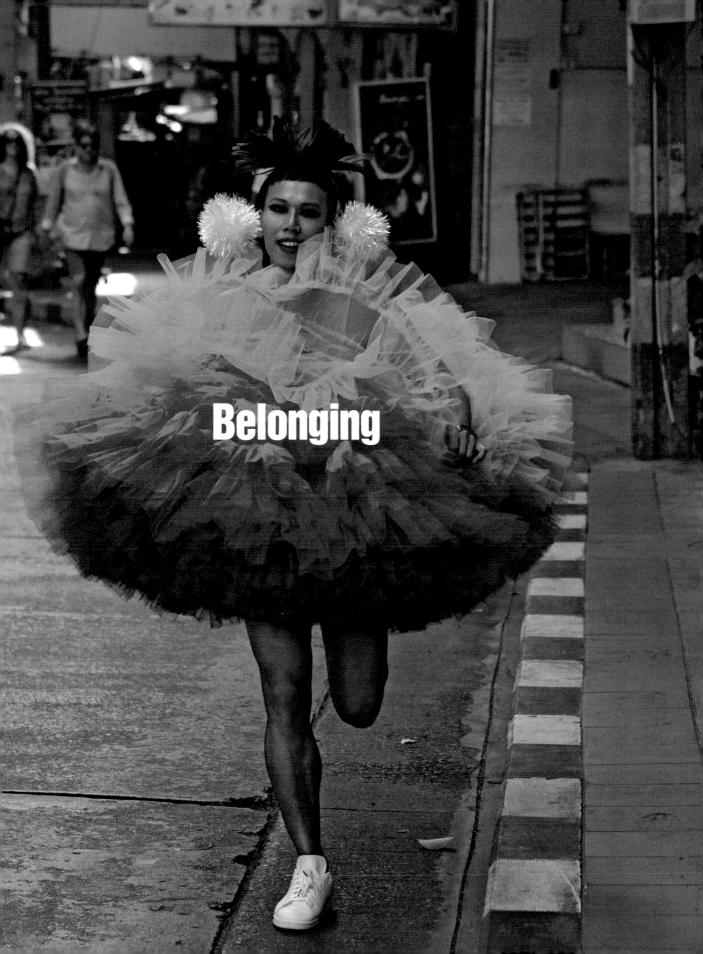

Belonging

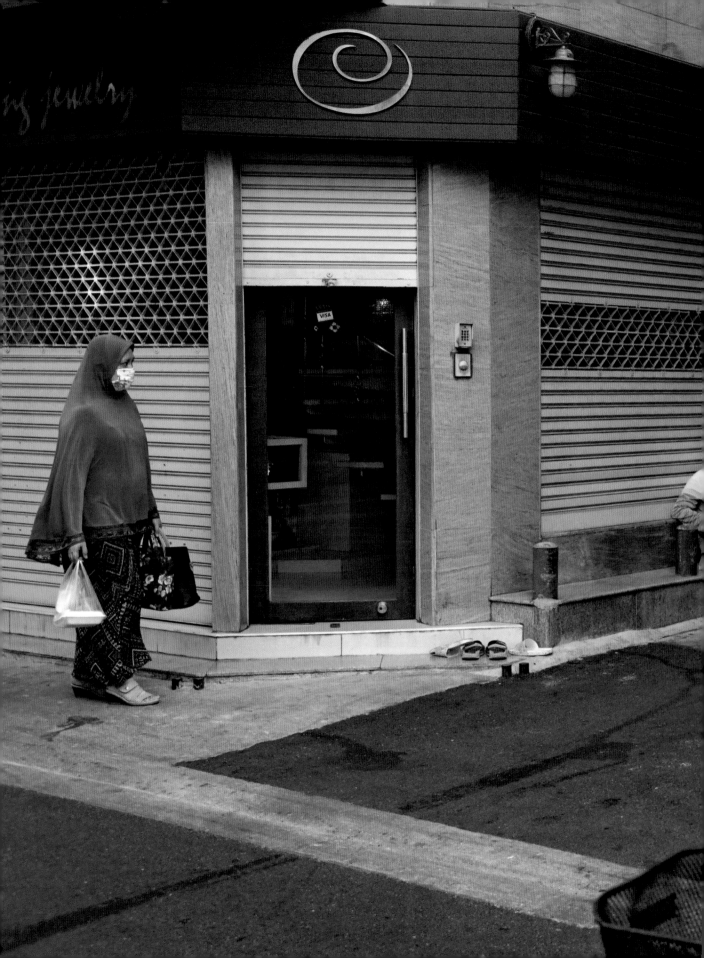

Belonging
Portraits from LGBTQ Thailand

Steve McCurry

THE NEW PRESS

Requests for permission to reproduce selections from this book should be made through
our website: https://thenewpress.com/contact.

Published in the United States by The New Press, New York, 2021
Distributed by Two Rivers Distribution

ISBN 978-1-62097-655-5 (pb)
ISBN 978-1-62097-656-2 (ebook)
CIP data is available

The New Press publishes books that promote and enrich public discussion and understanding of
the issues vital to our democracy and to a more equitable world. These books are made possible
by the enthusiasm of our readers; the support of a committed group of donors, large and small;
the collaboration of our many partners in the independent media and the not-for-profit sector;
booksellers, who often hand-sell New Press books; librarians; and above all by our authors.

www.thenewpress.com

Book design and composition © 2021 by Emerson, Wajdowicz Studios (EWS)
This book was set in FF Meta, Franklin Gothic, Helvetica Inserat, Helvetica Neue, News Gothic,
Plex Sans Thai Looped and Zapf Dingbats

Printed in the United States of America

10 9 8 7 6 5 4 3 2 1

Preface
JON STRYKER

The project was born out of conversations that I had with Jurek Wajdowicz. He is an accomplished art photographer and frequent collaborator of mine, and I am a lover of and collector of photography. I owe a great debt to Jurek and his design partner, Lisa LaRochelle, in bringing this book series to life.

Both Jurek and I have been extremely active in social justice causes—I as an activist and philanthropist and he as a creative collaborator with some of the household names in social change. Together we set out with an ambitious goal to explore and illuminate the most intimate and personal dimensions of self, still too often treated as taboo: sexual orientation and gender identity and expression. These books continue to reveal the amazing multiplicity in these core aspects of our being, played out against a vast array of distinct and varied cultures and customs from around the world.

Photography is a powerful medium for communication that can transform our understanding and awareness of the world we live in. We believe the photographs in this series will forever alter our perceptions of the arbitrary boundaries that we draw between others and ourselves and, at the same time, delight us with the broad spectrum of possibility for how we live our lives and love one another.

We are honored to have Steve McCurry as a collaborator in *Belonging*. He, and the other photographers in this ongoing series, are more than craftspeople: they are communicators, translators, and facilitators of the kind of exchange that we hope will eventually allow all the world's people to live in greater harmony. ■

Jon Stryker, philanthropist, architect, and photography devotee, is the founder and board president of the Arcus Foundation, a global foundation promoting respect for diversity among peoples and in nature.

Boonjira บุญจิรา

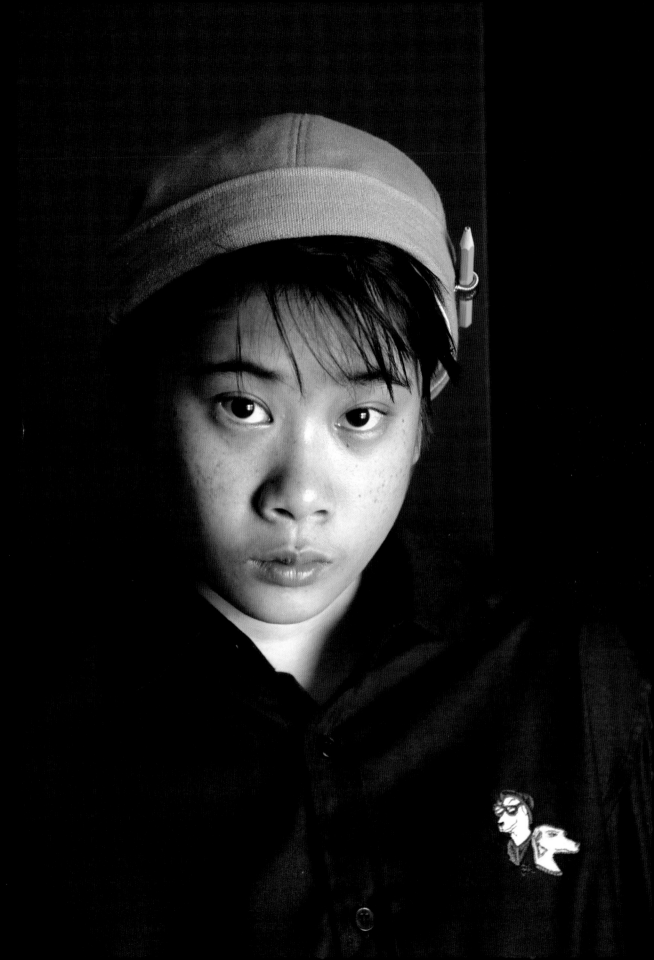

Nitinan นิธินันท์

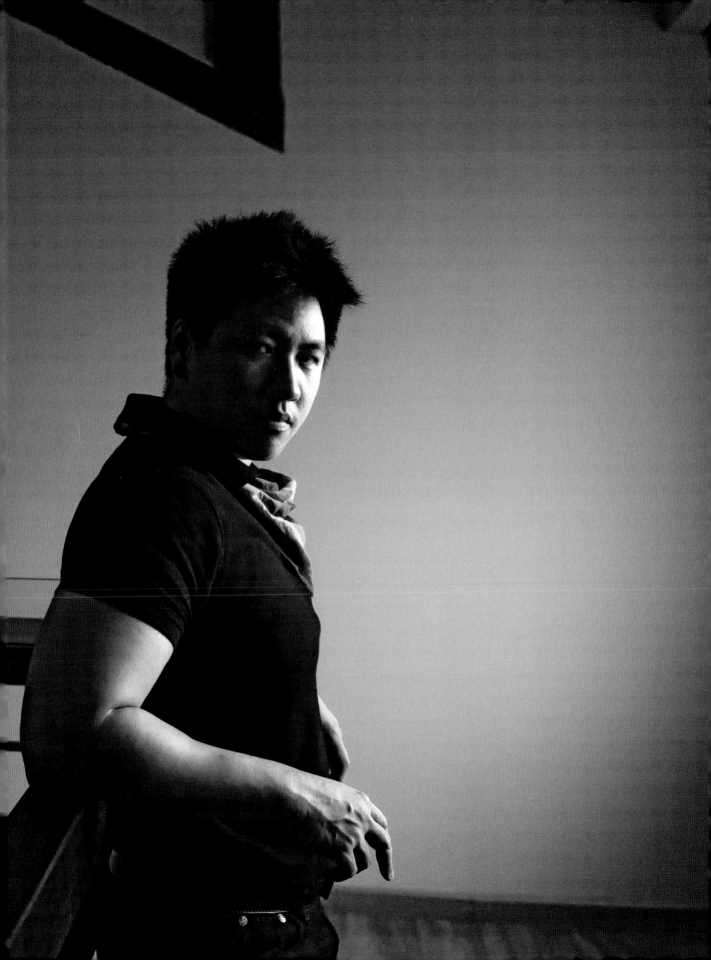

Areerut อารีรัตน์

Rojjanaruch โรจณรัซญ์

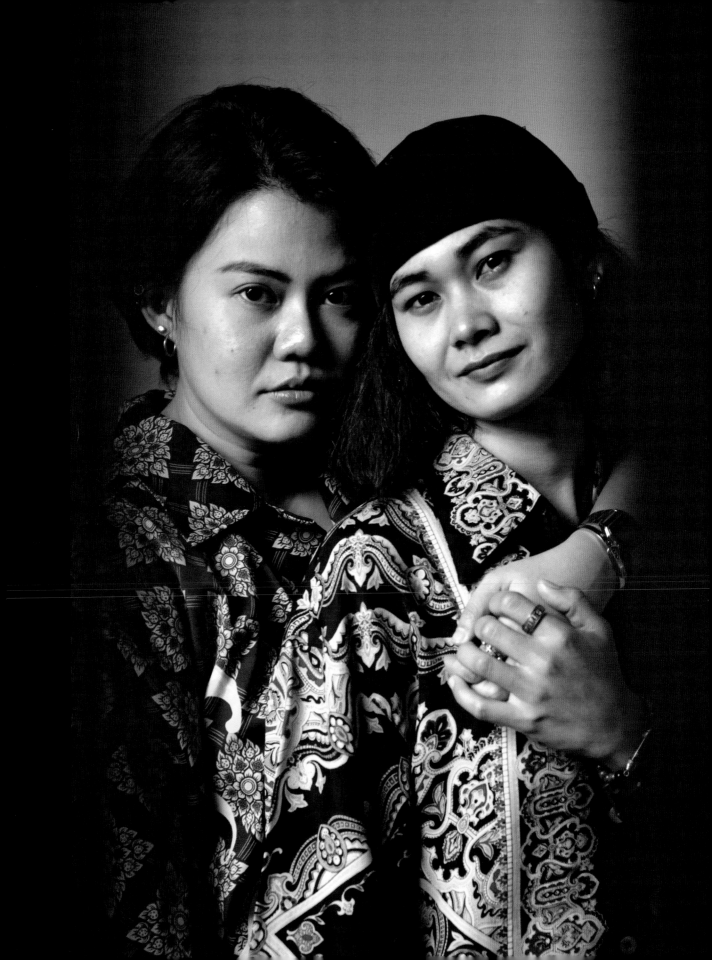

Assadayut
อัษฎายุทธ

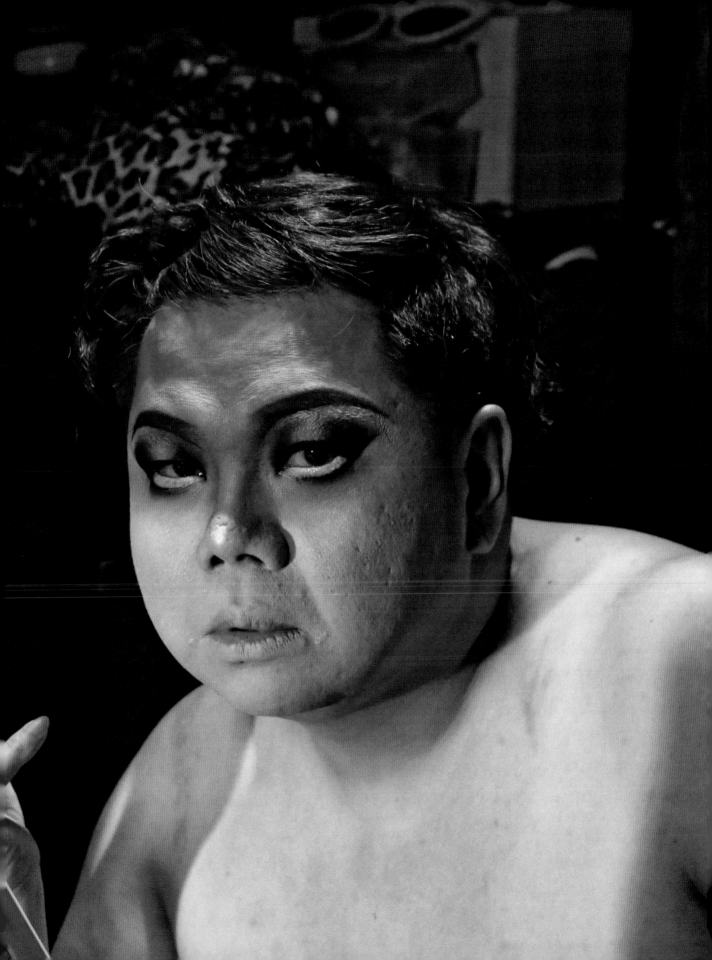

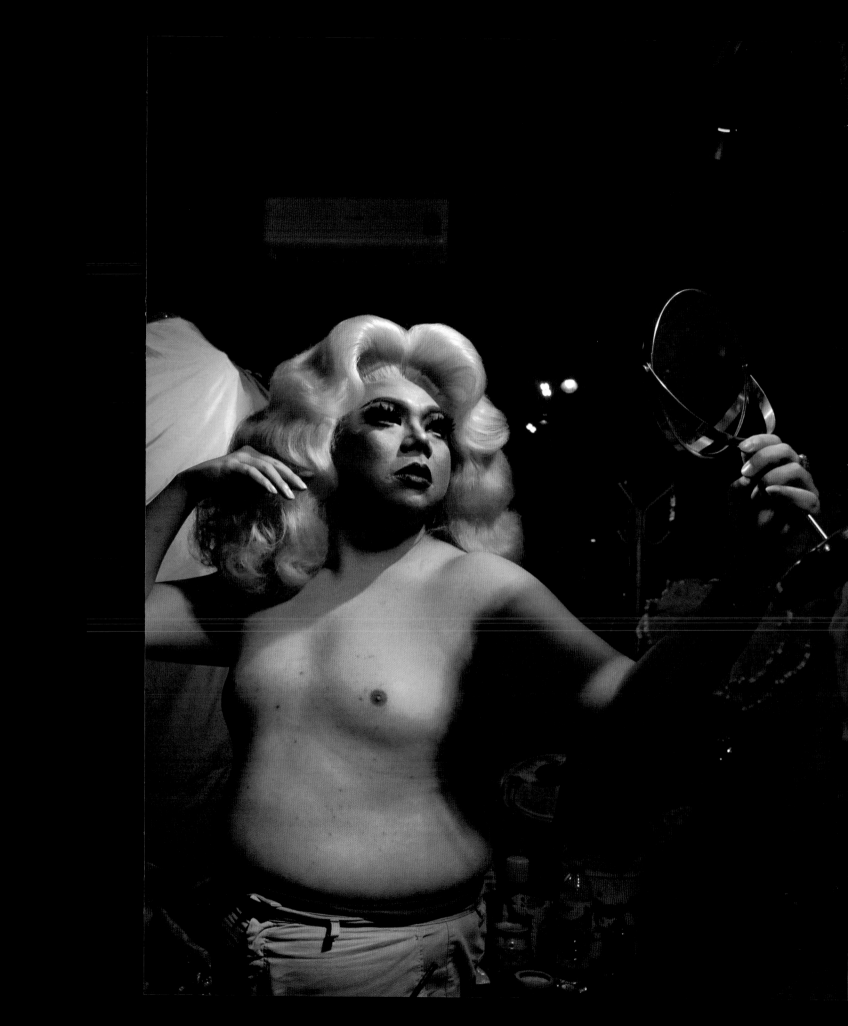

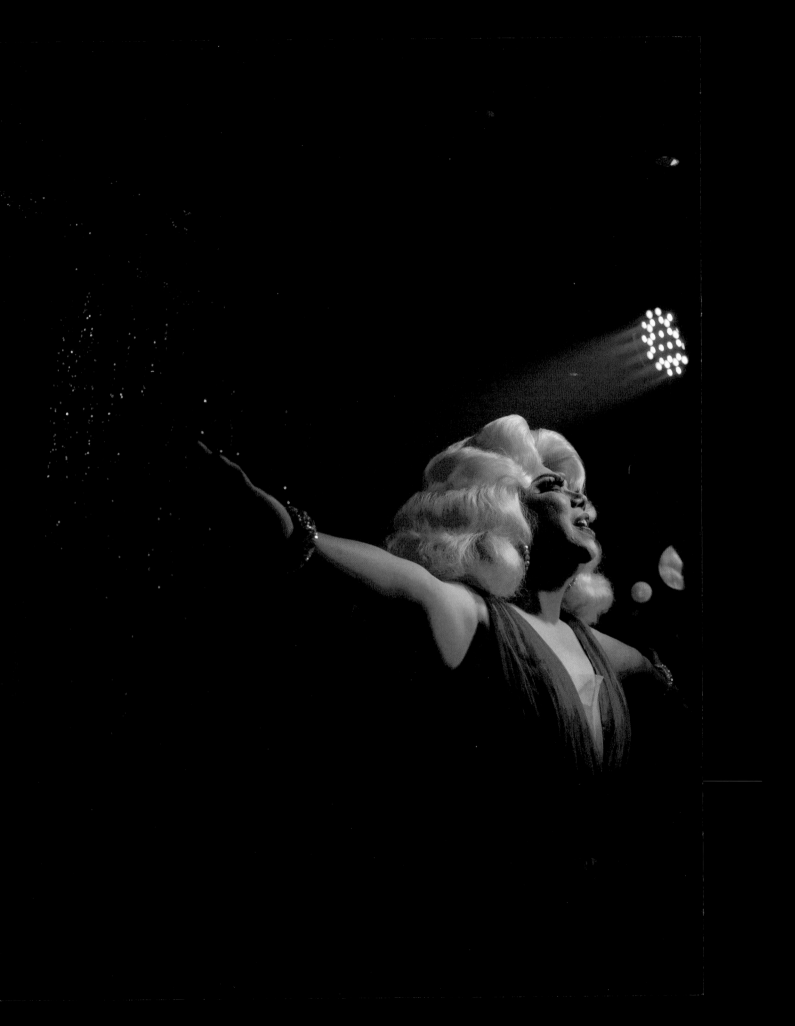

Kittinun
กิตตินันท์

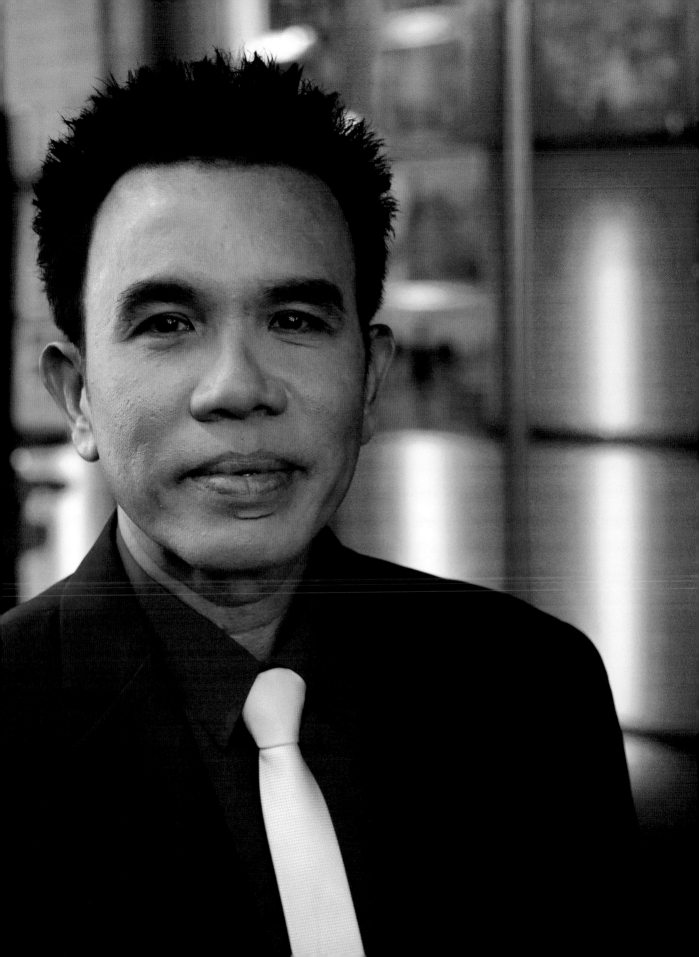

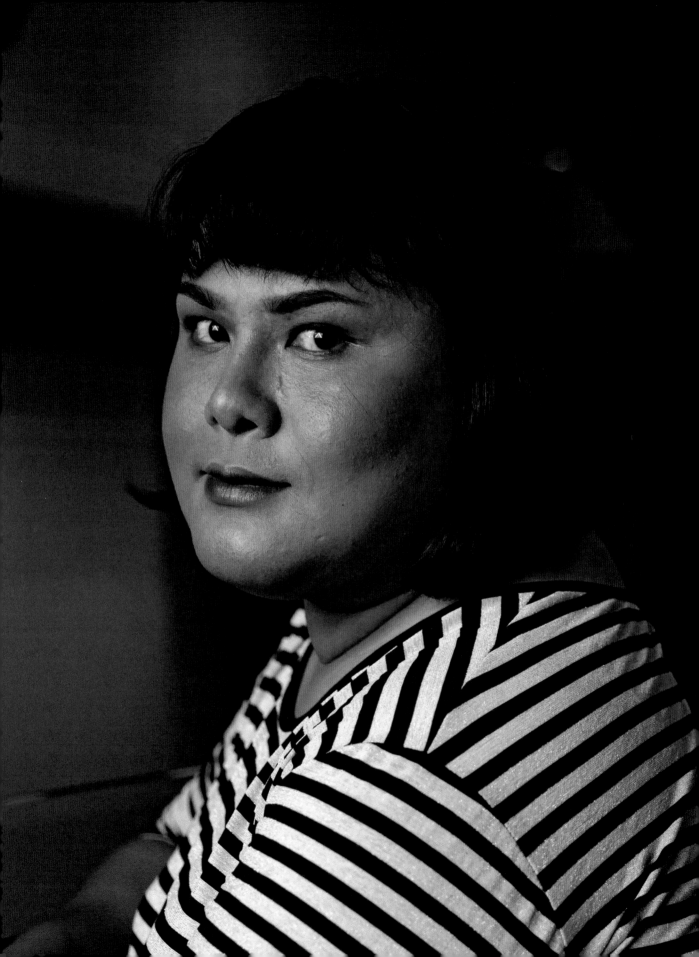

Pat ปัถย์

Cedric เซดริก
Watcharin วัชรินทร์

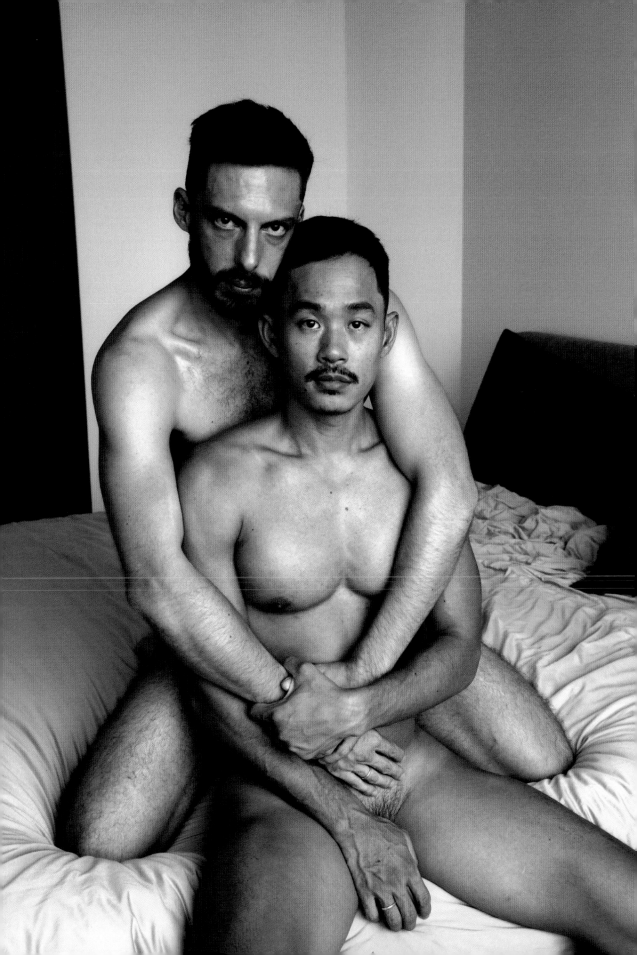

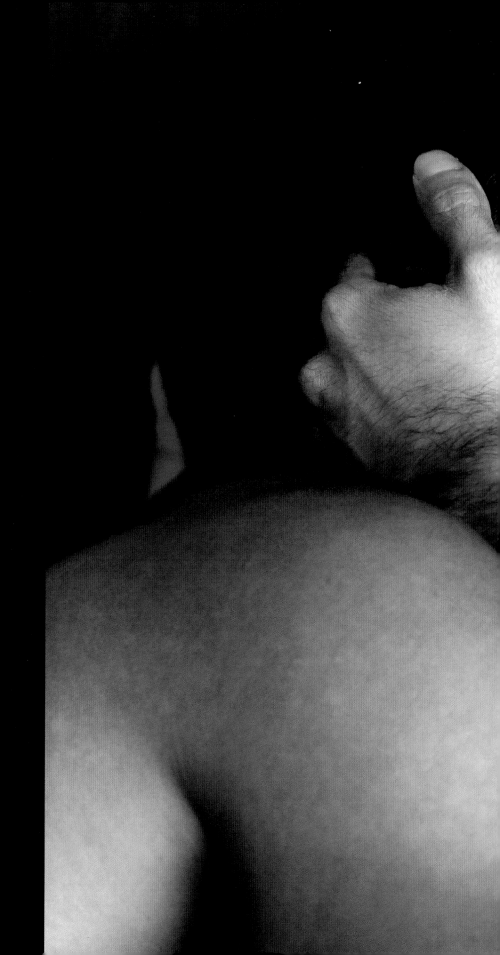

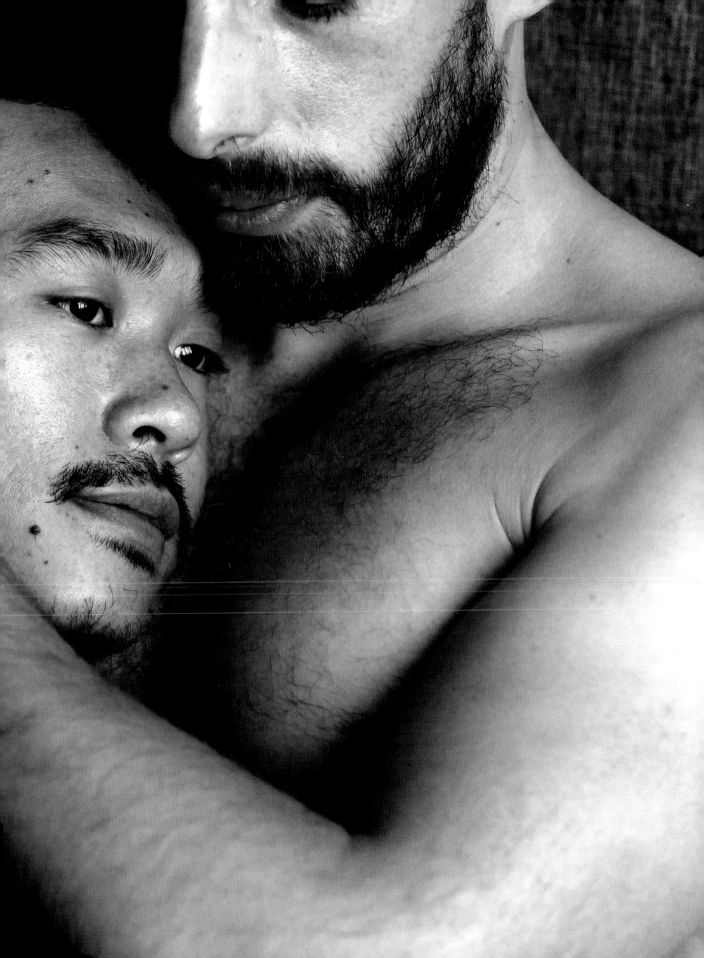

Jatupong จตุพงศ์

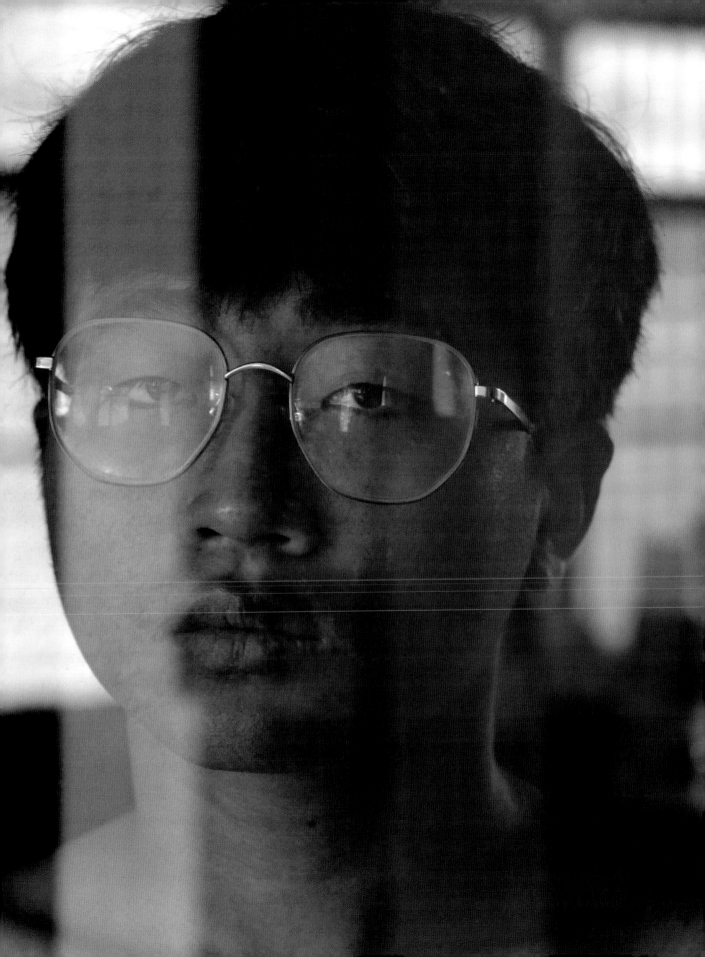

Pichai พิชัย

Thomas โทมัส

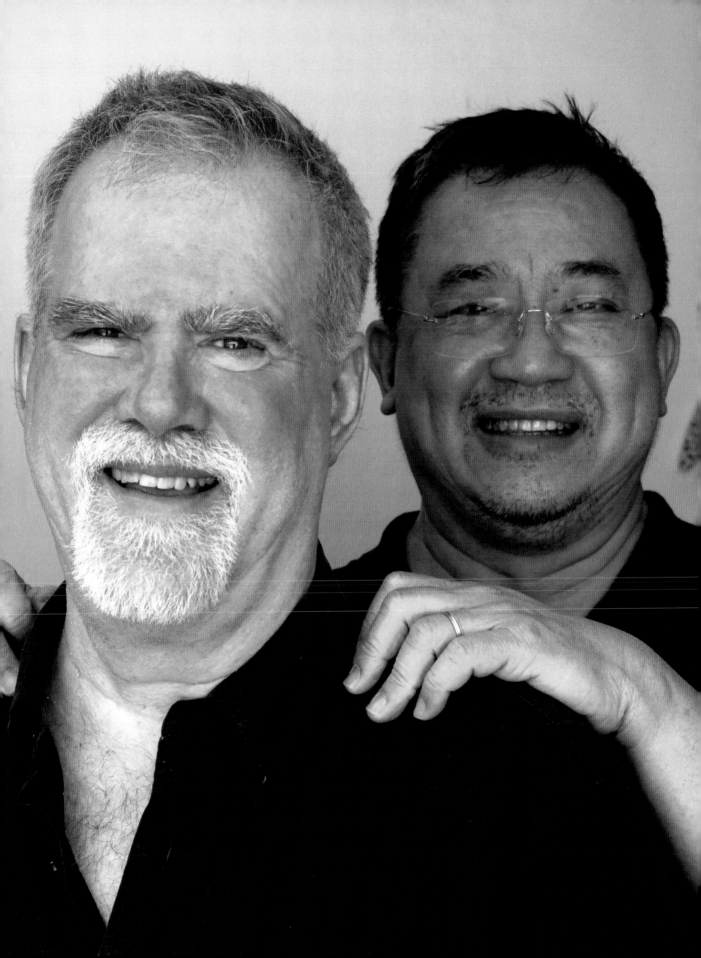

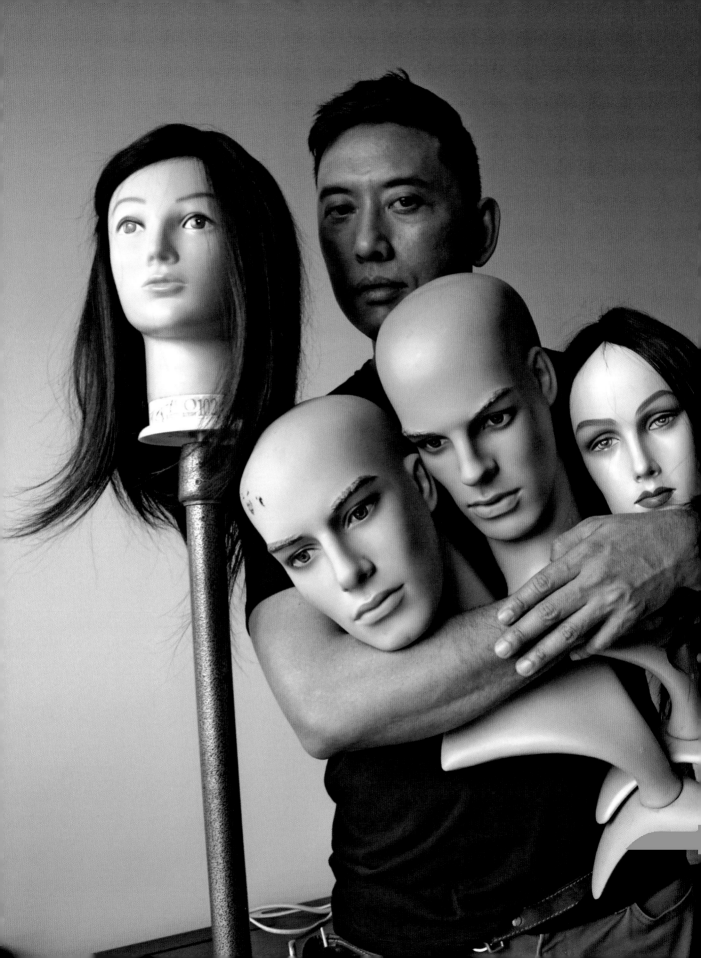

Kongyos คงยศ

Kris กฤศ

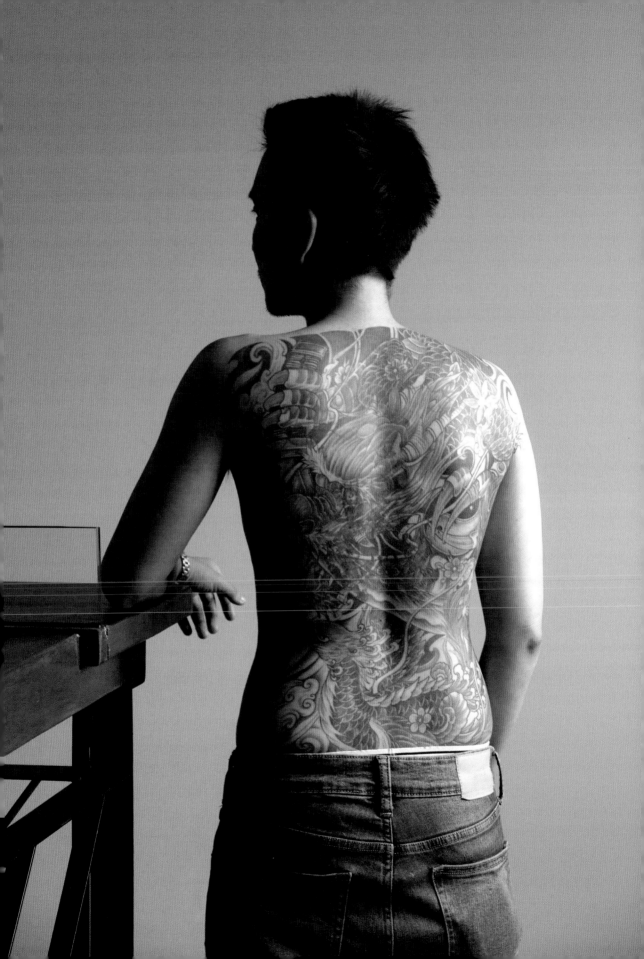

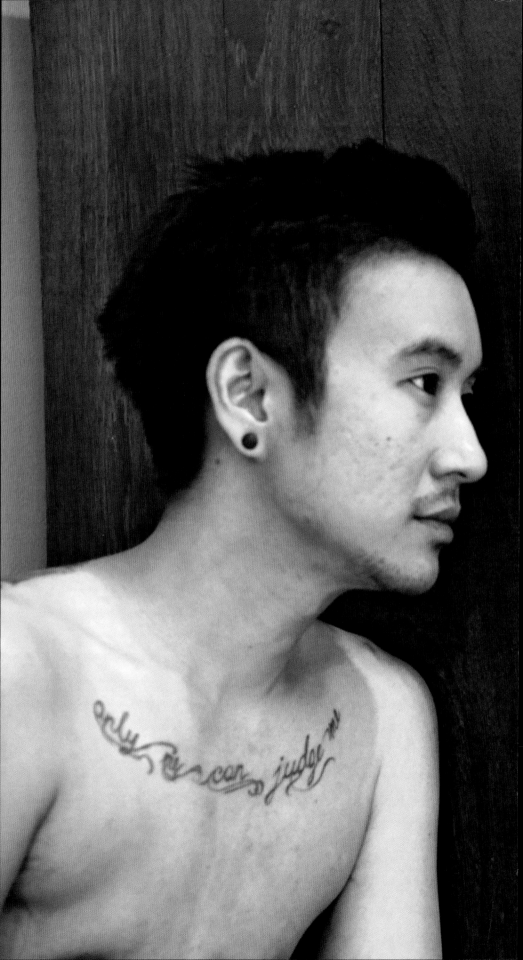

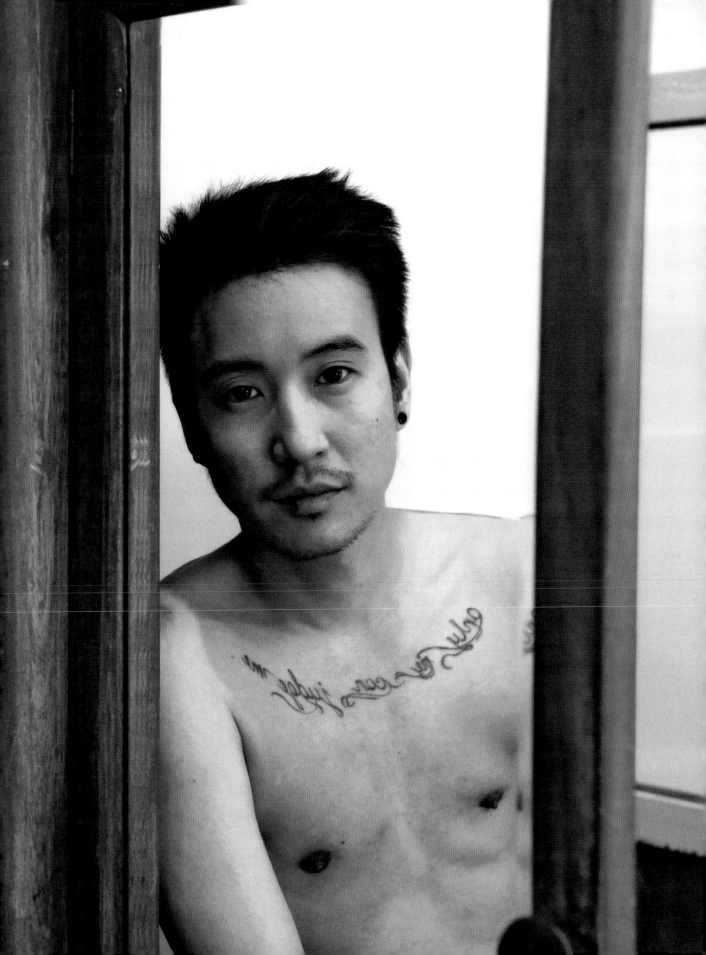

Pauline พอลลีน

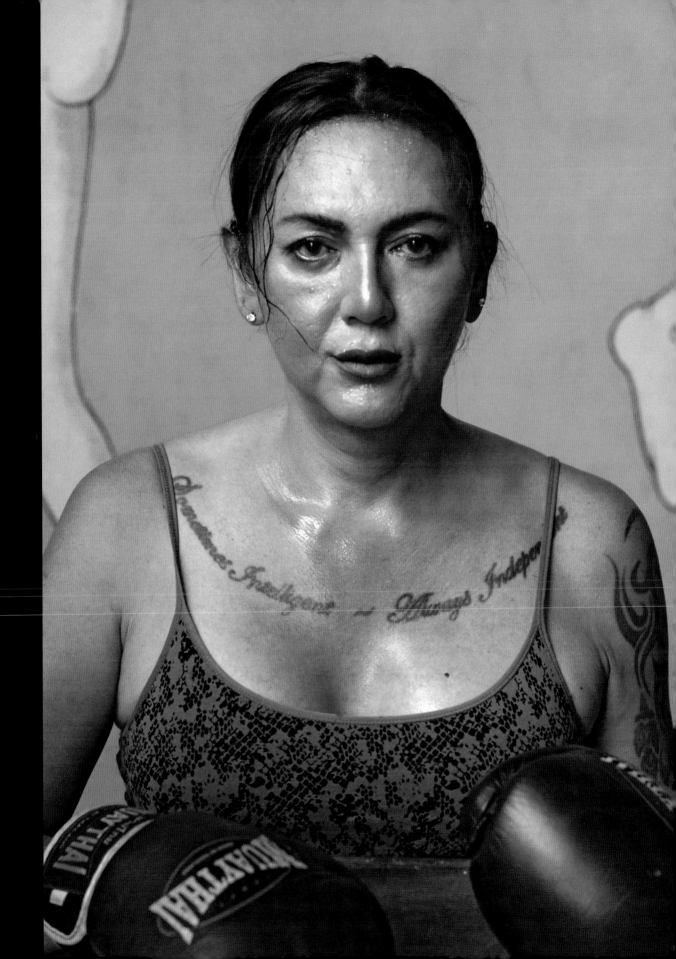

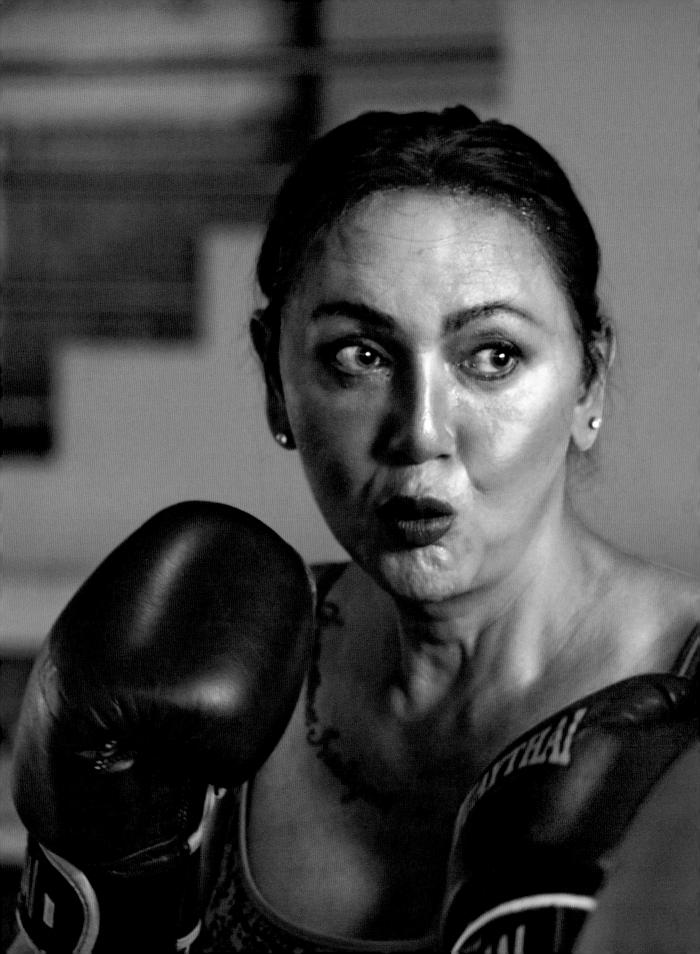

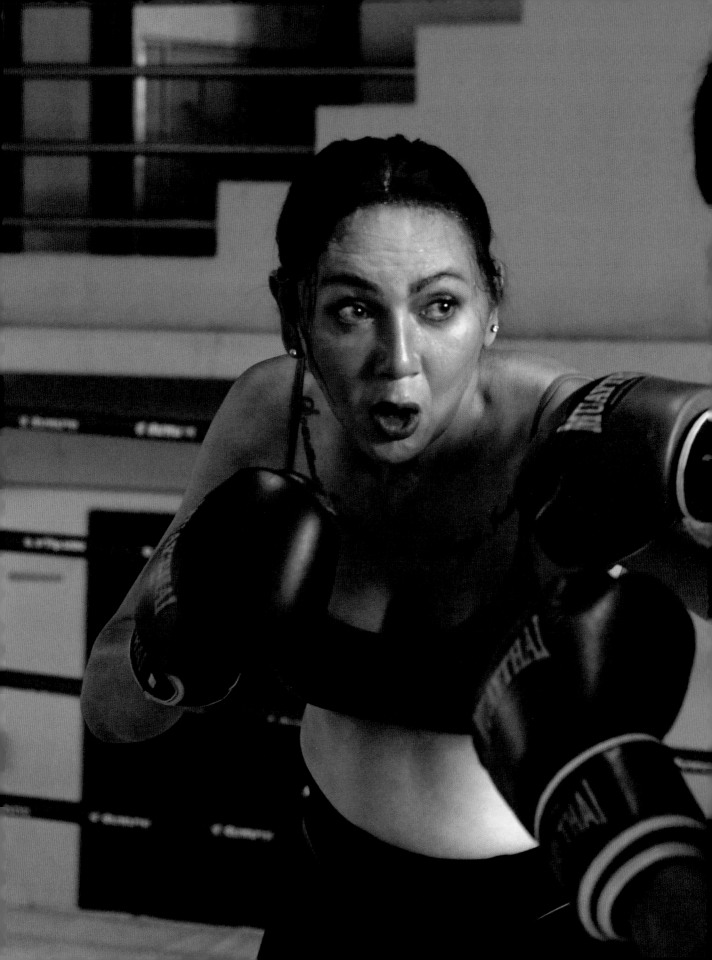

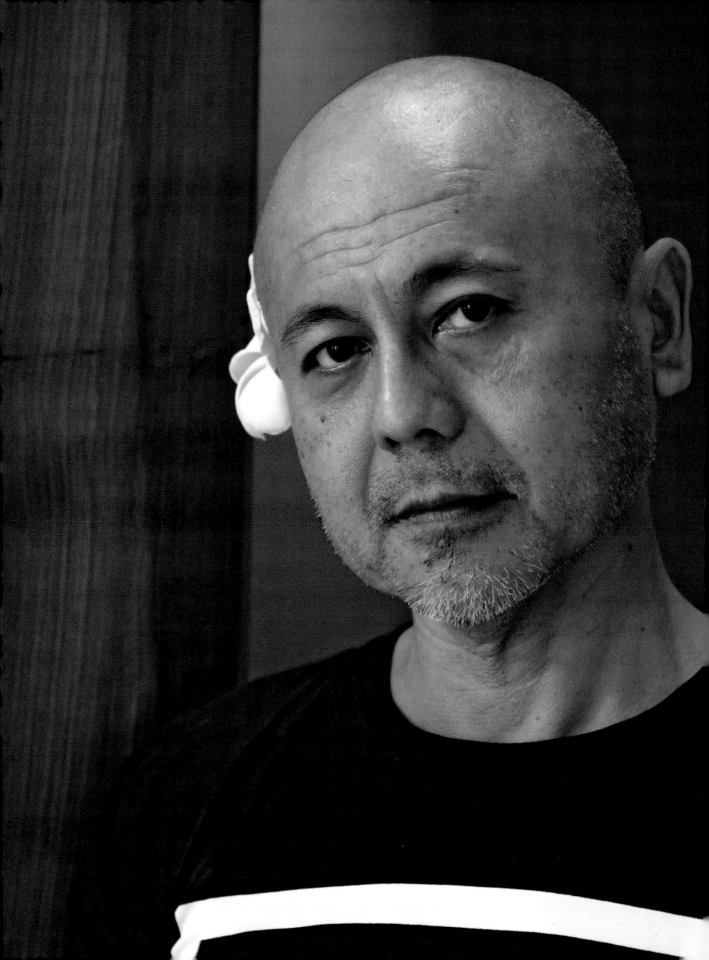

Michael ไมเคิ้ล

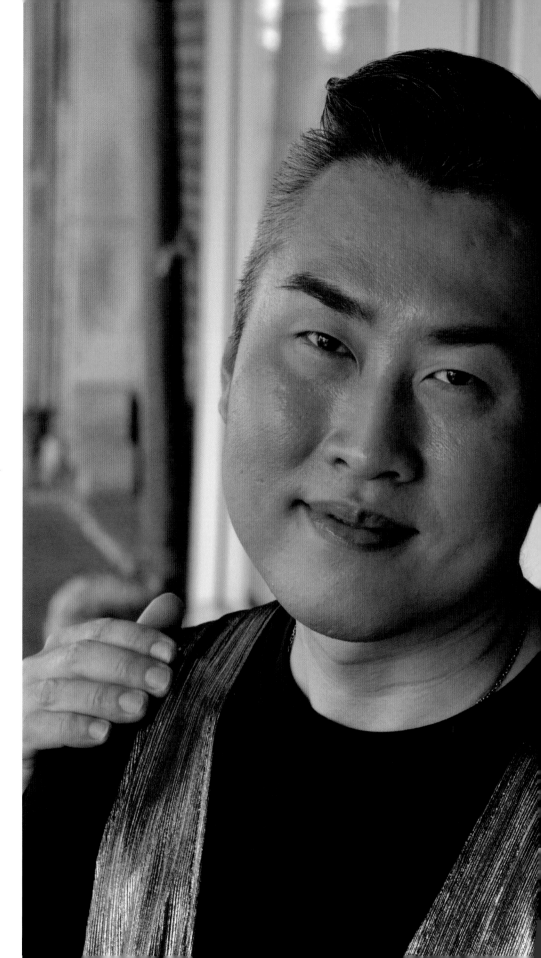

Jitsak จิตศักดิ์

Geoffrey เจฟฟรีย์

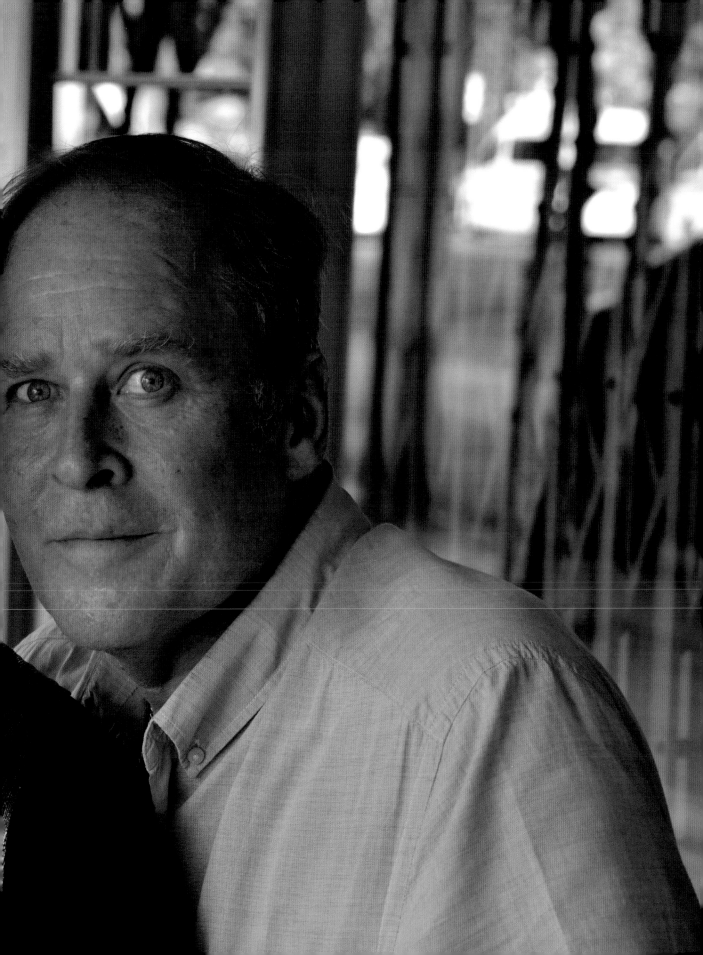

Anjana อัญชนา

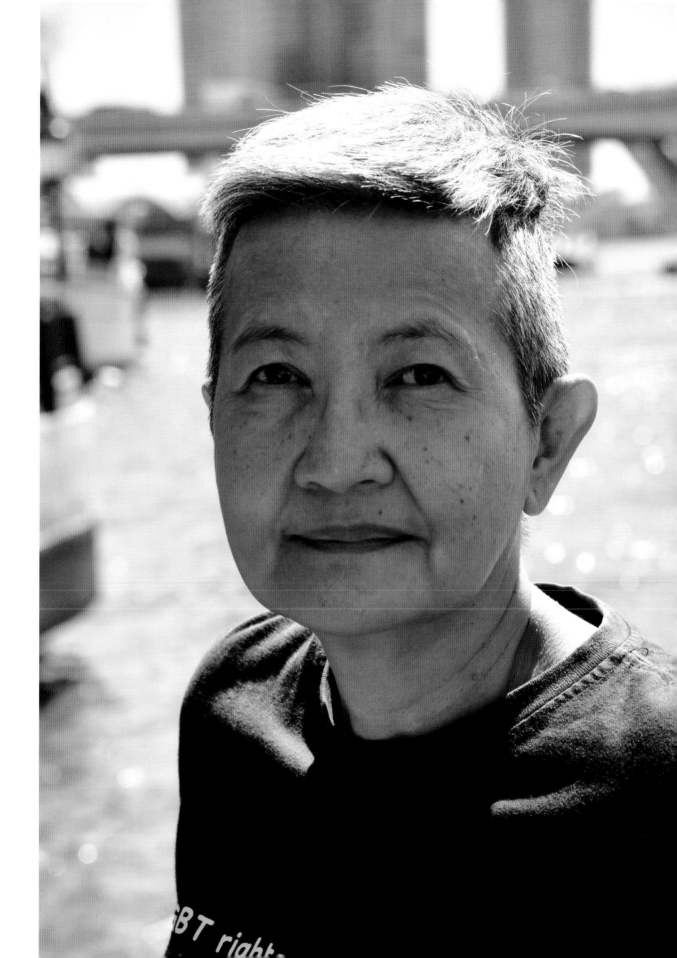

Poomjai ภูมิใจ

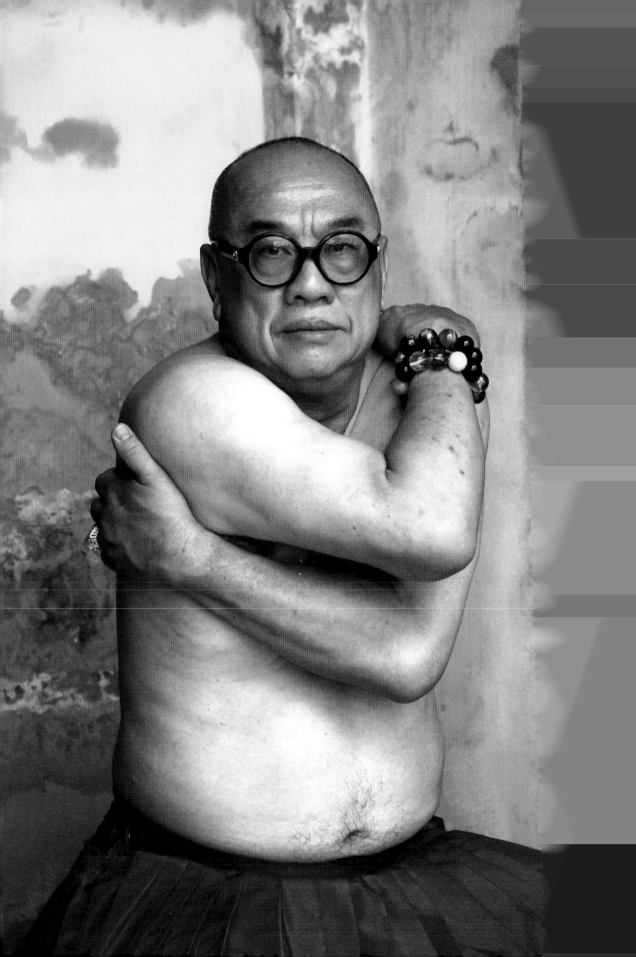

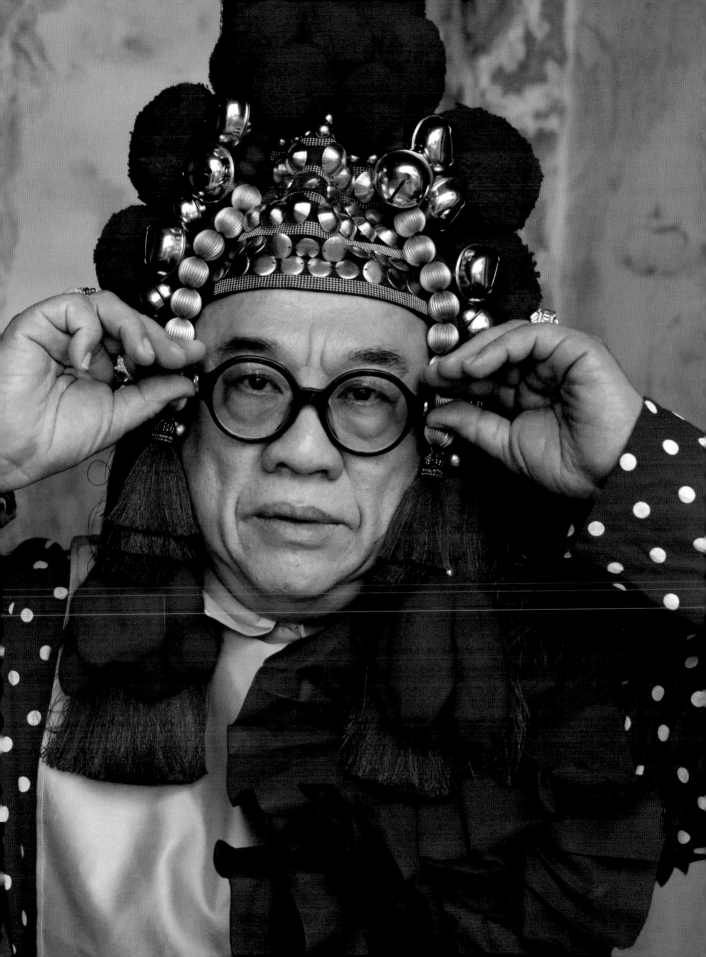

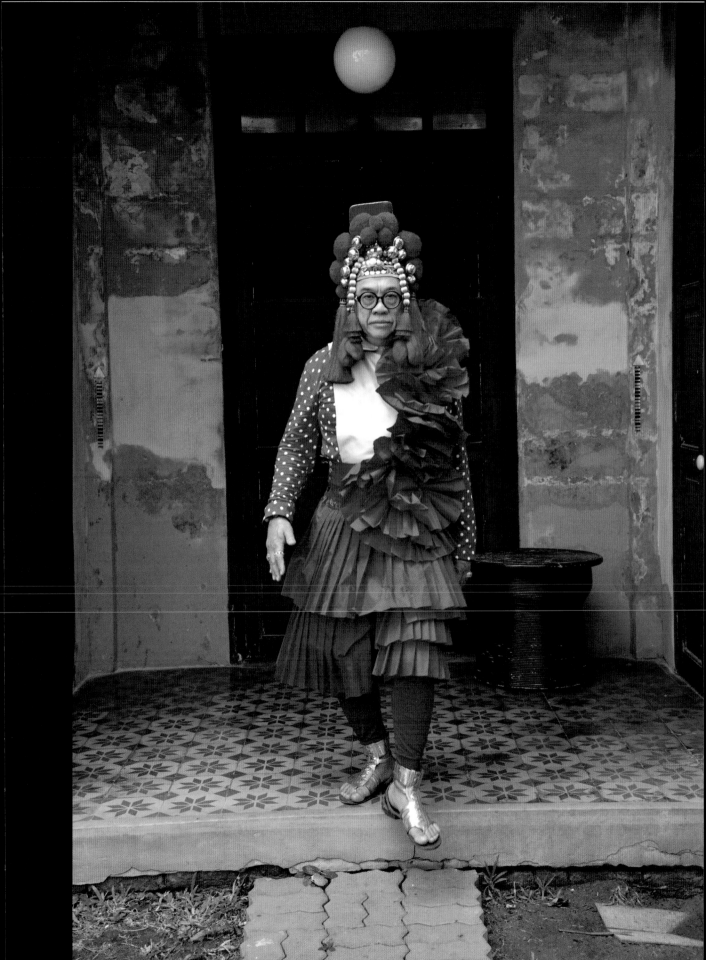

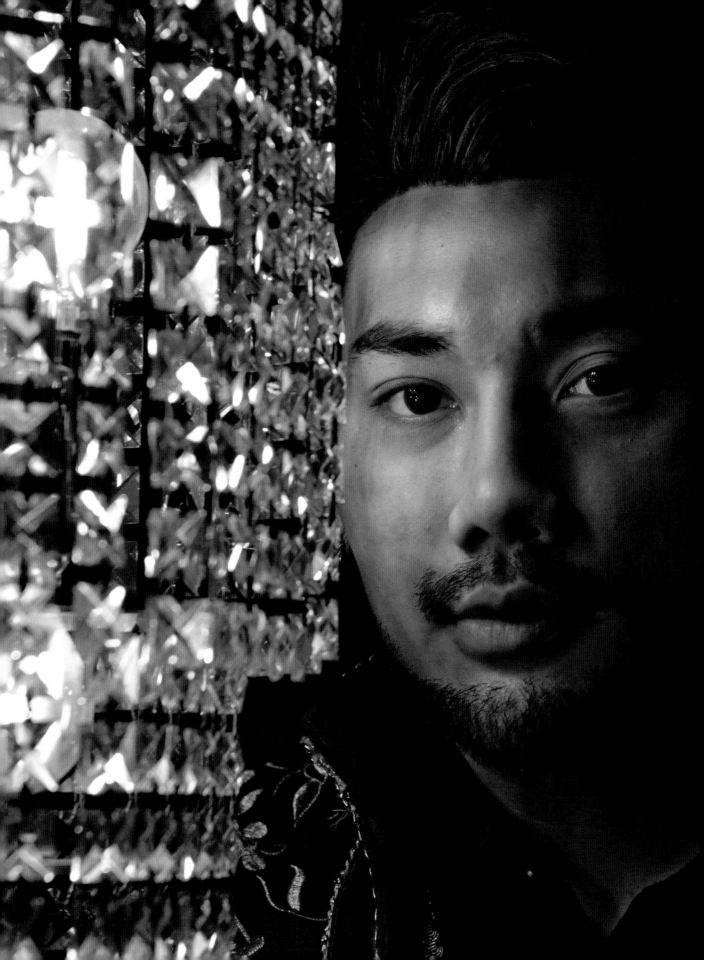

Jirayu จิรายุ

Arayaissaree อารยาอิสรีย์

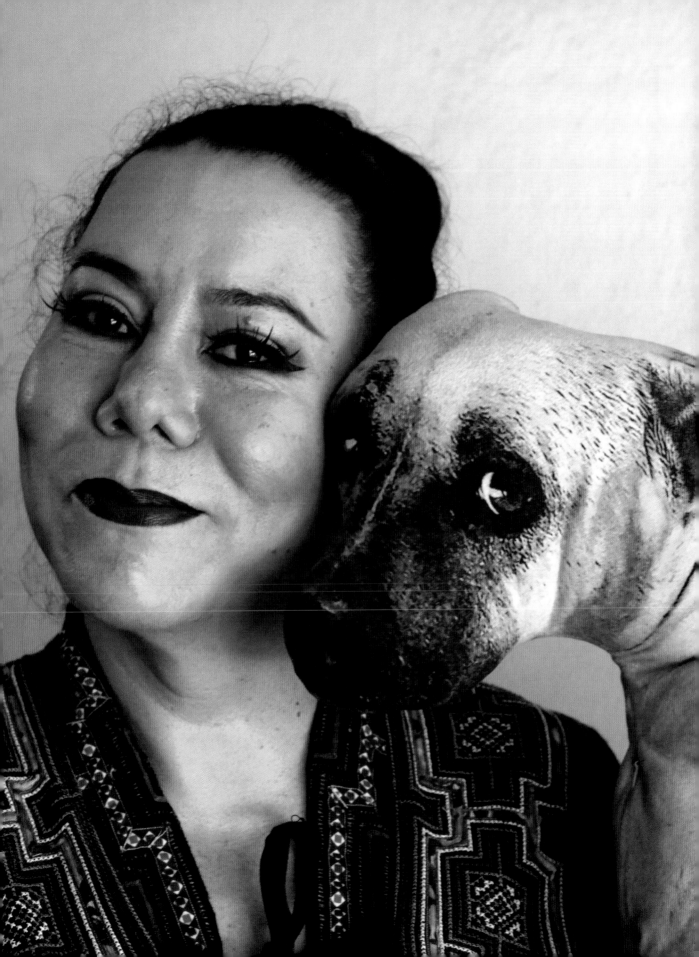

Apichet อภิเชษฐ์

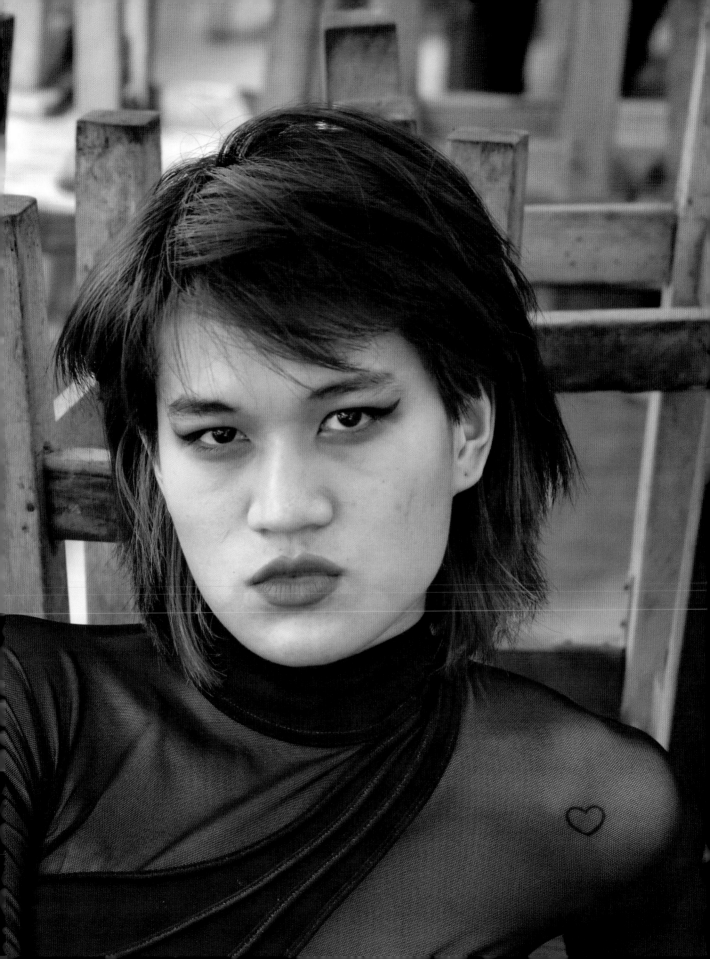

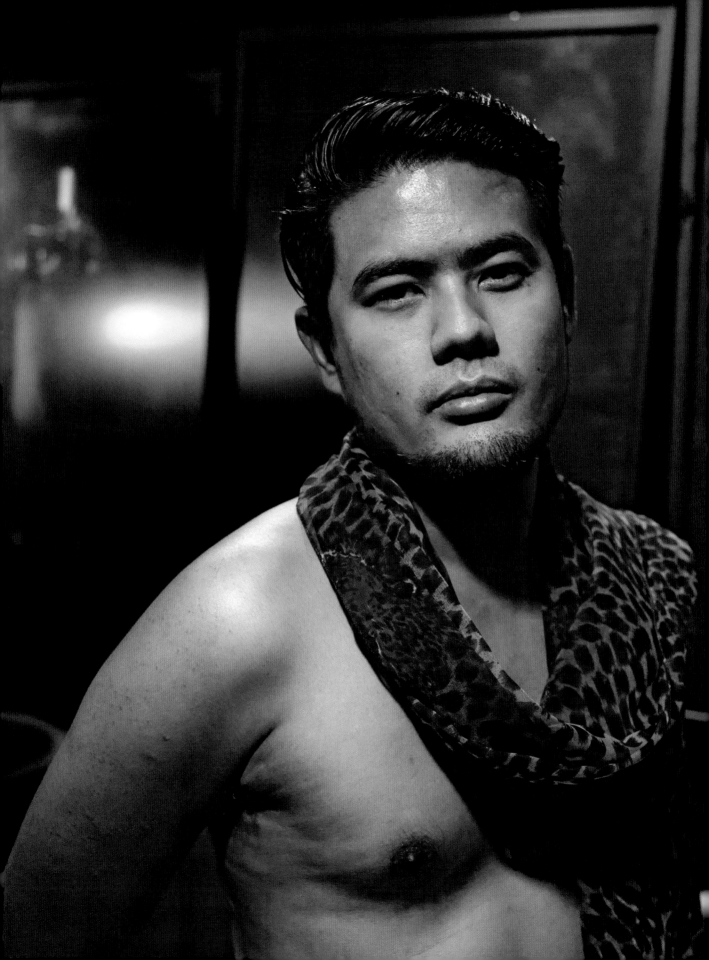

Naphat P. ณ พัทธ์

Chitsanupong
ชิษณุพงศ์

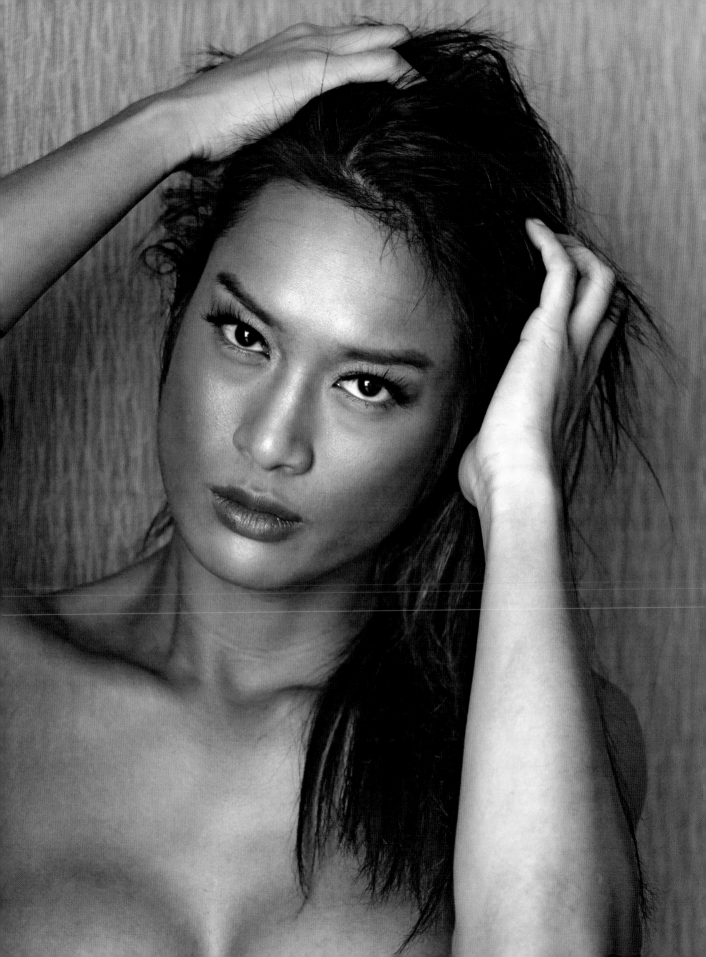

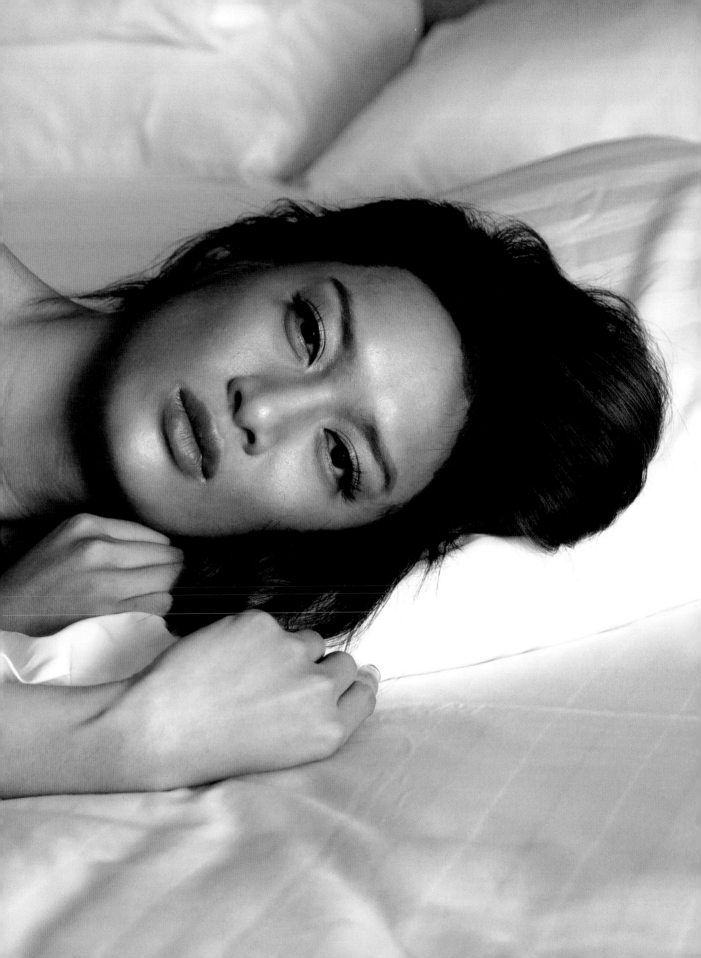

Dechanan
เดชนันท์

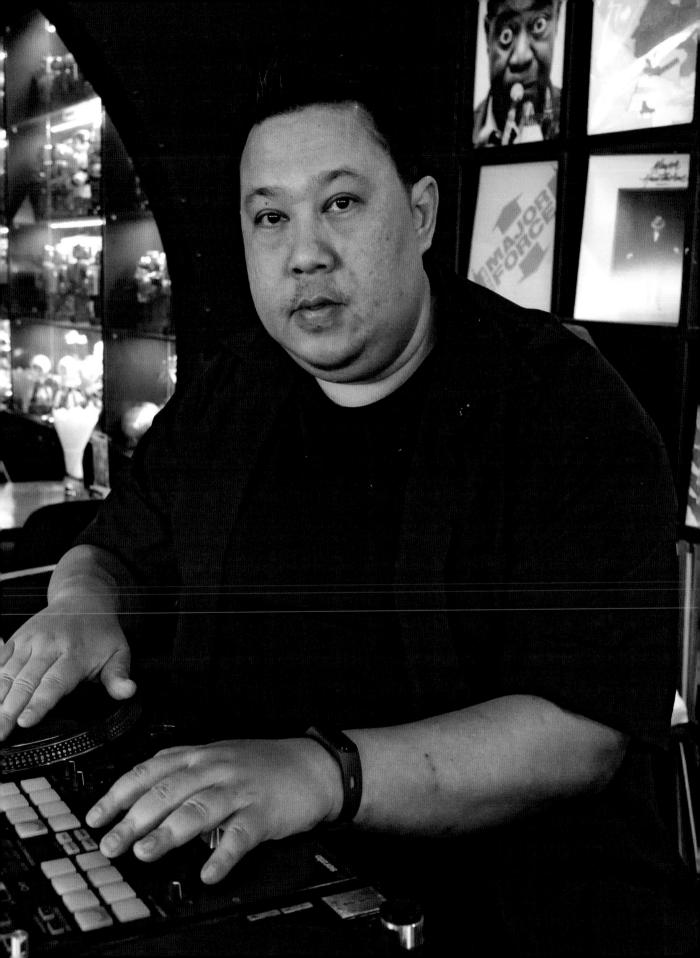

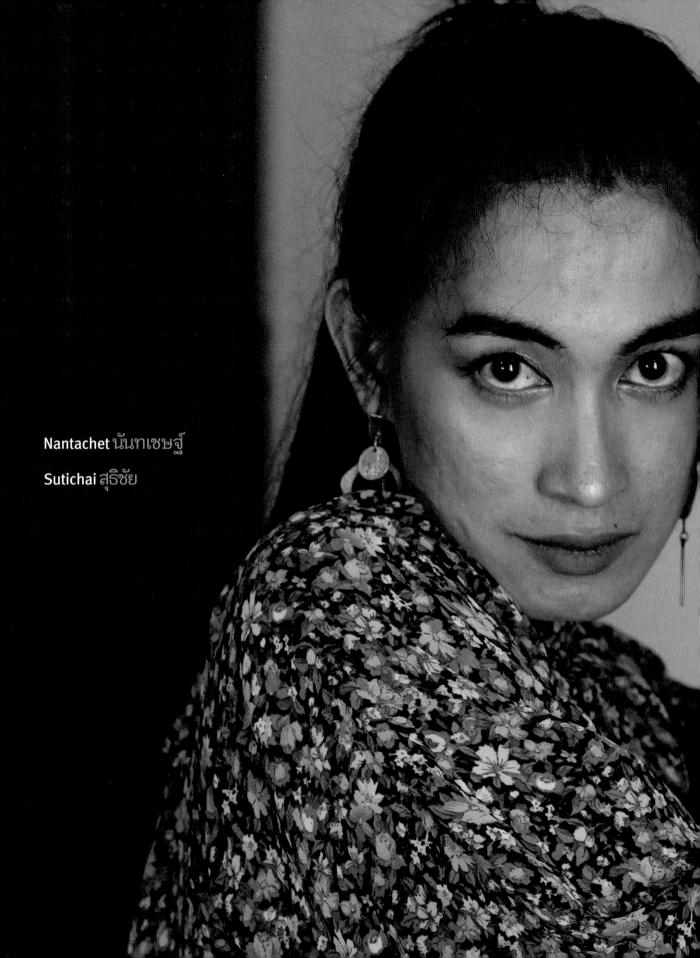

Nantachet นันทเชษฐ์

Sutichai สุธิชัย

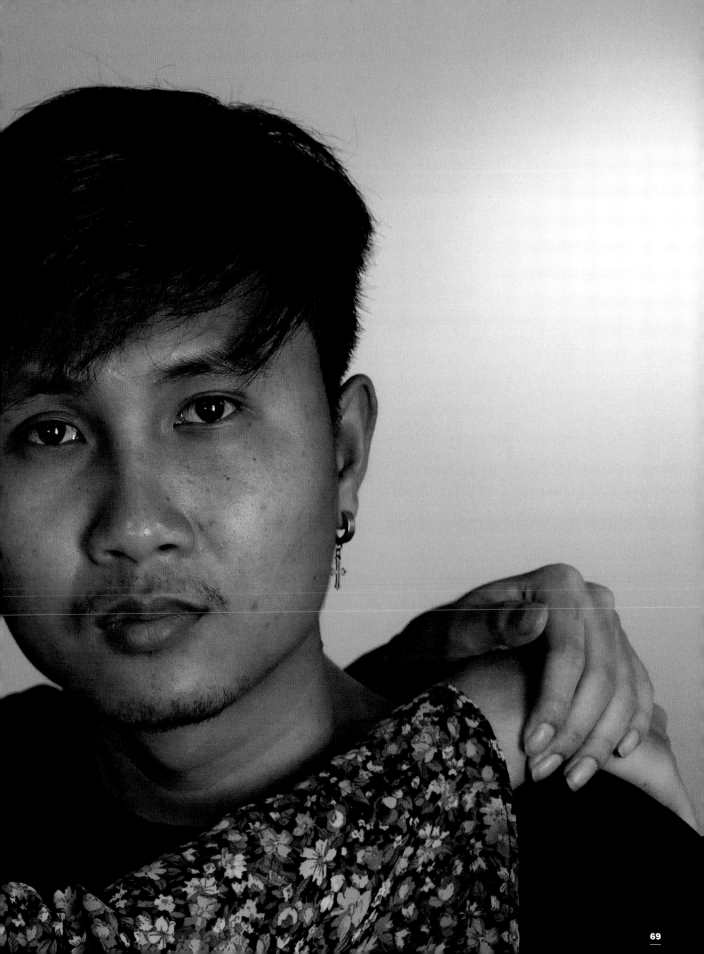

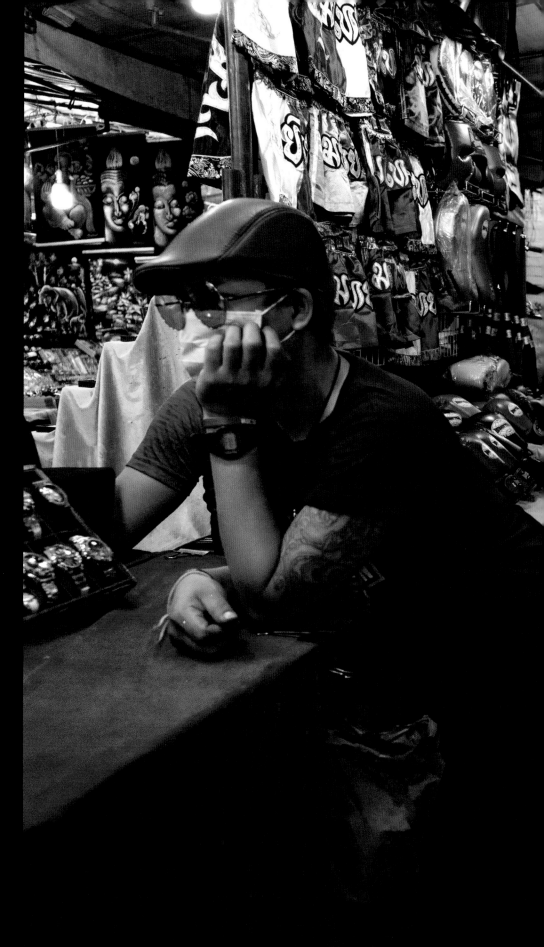

Khemngern
เข็มเงิน

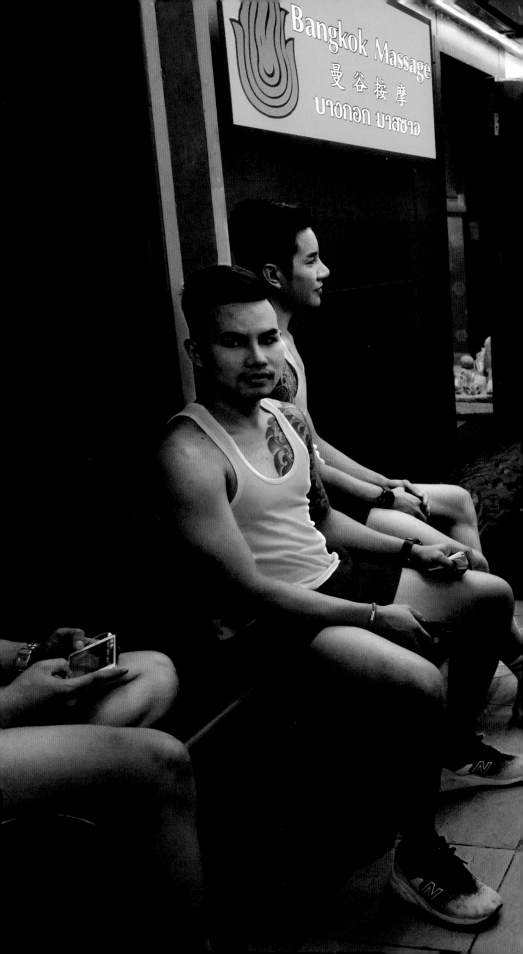

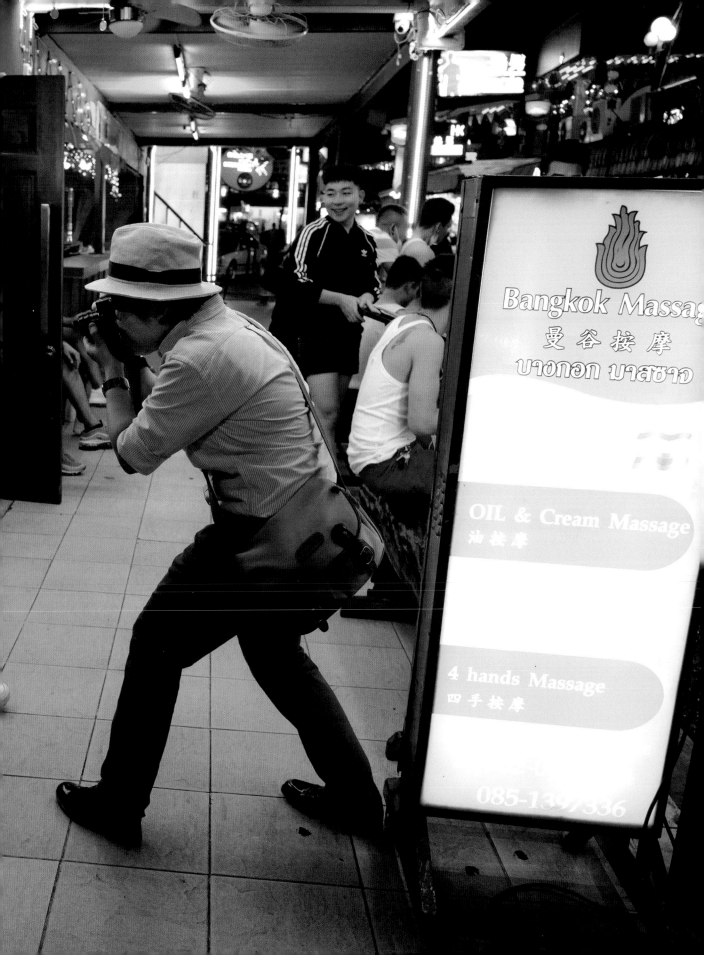

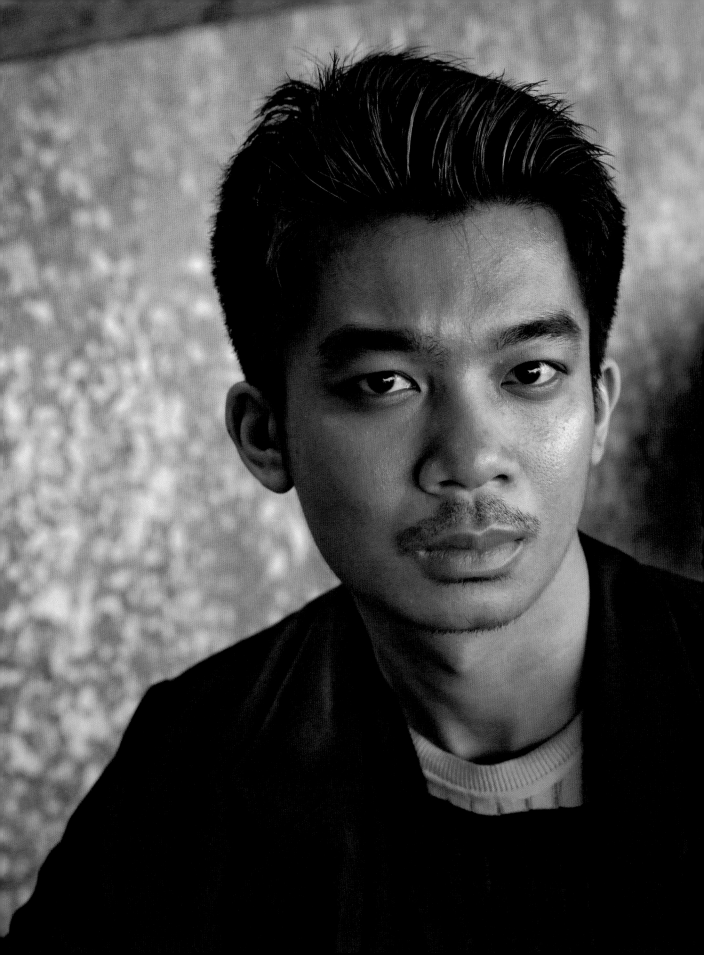

Paradorn ภราดร

Panatda ปนัดดา

Usa อุษา

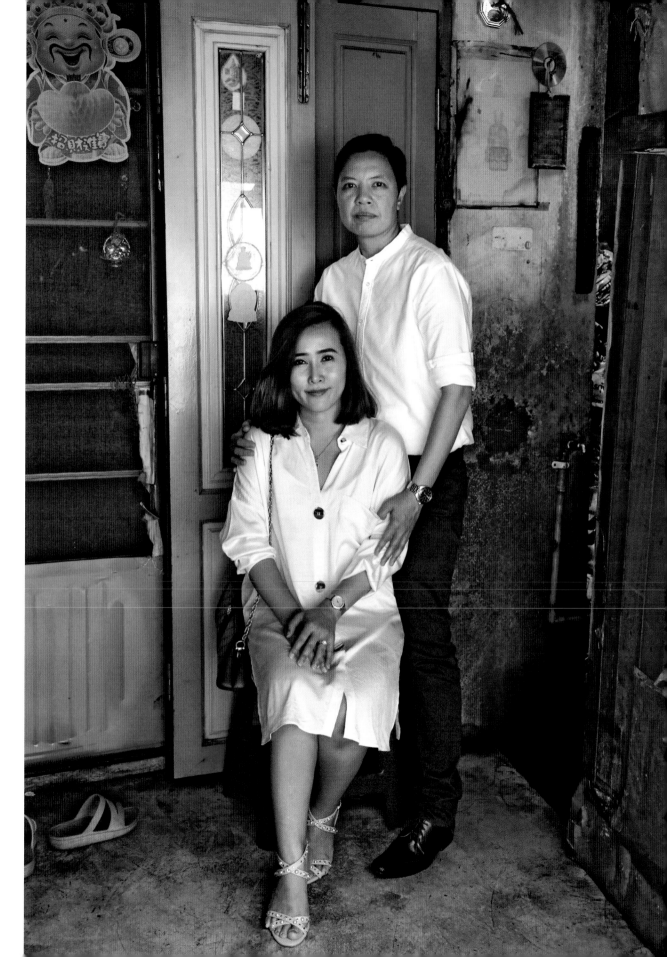

Sornchai ศรชัย

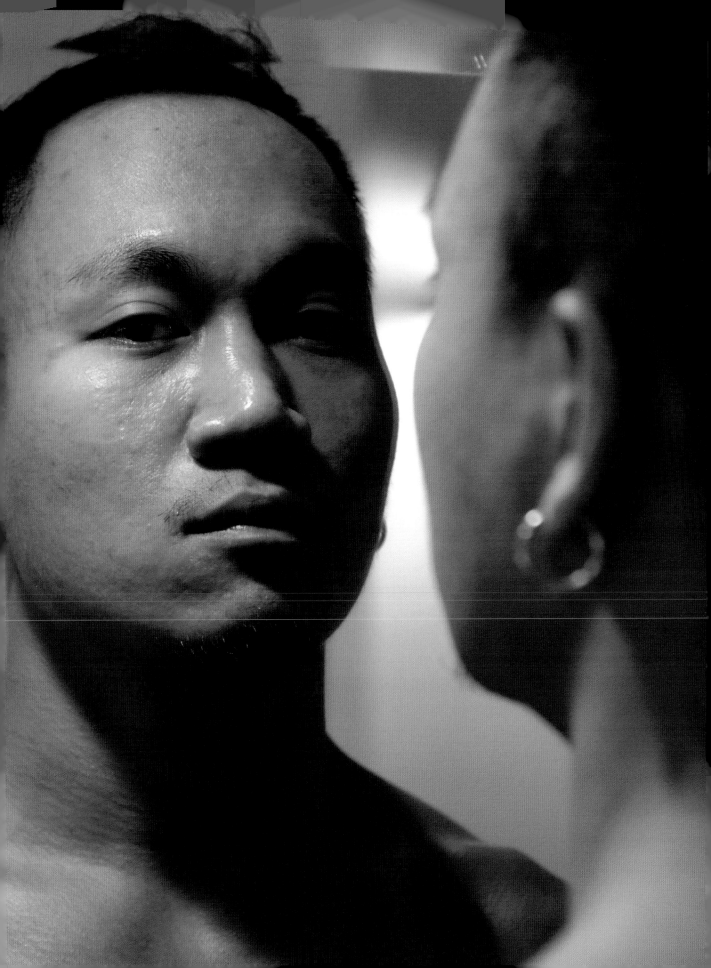

Theerayut
ธีระยุทธ

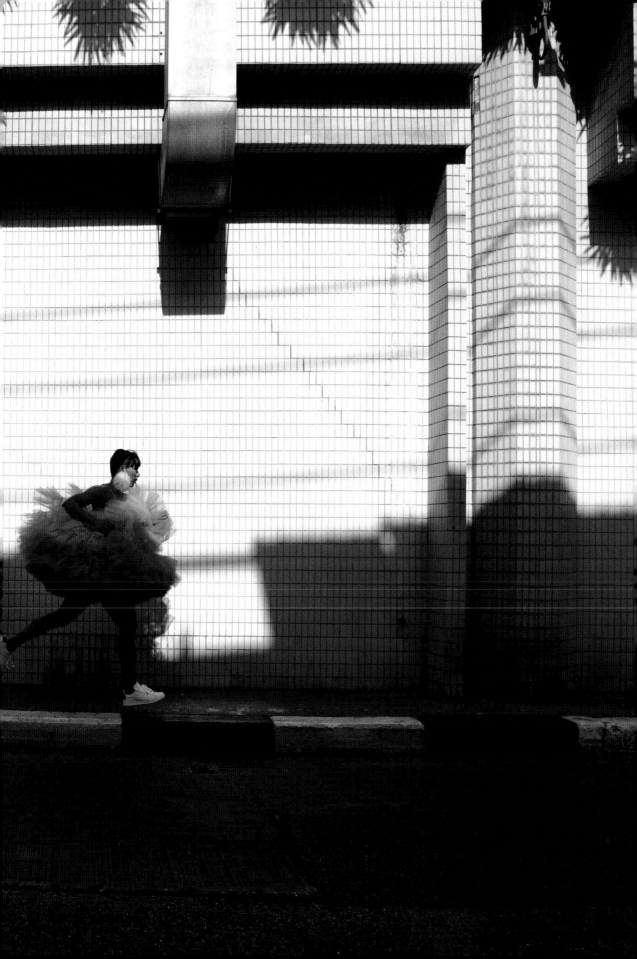

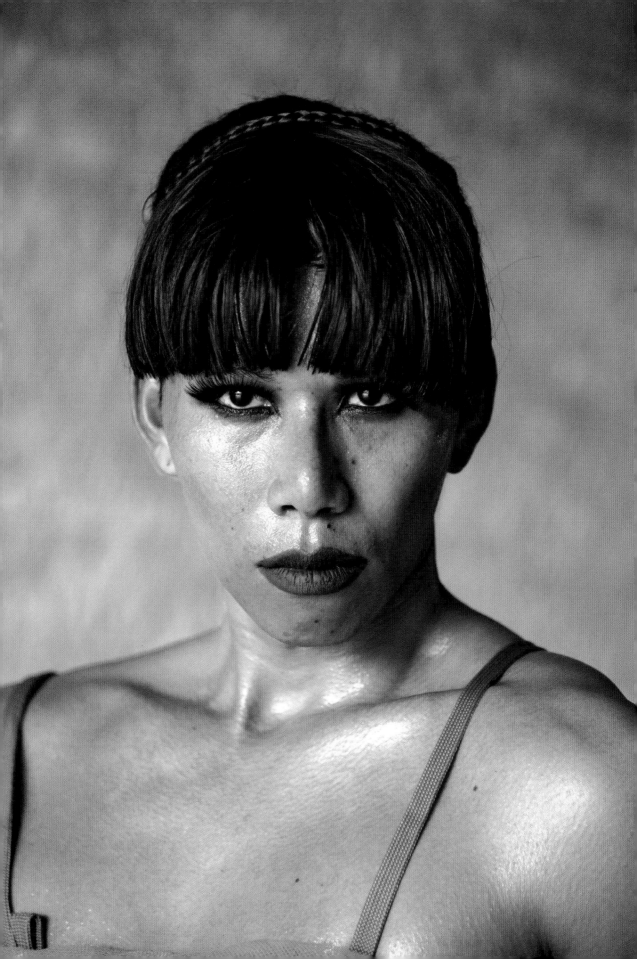

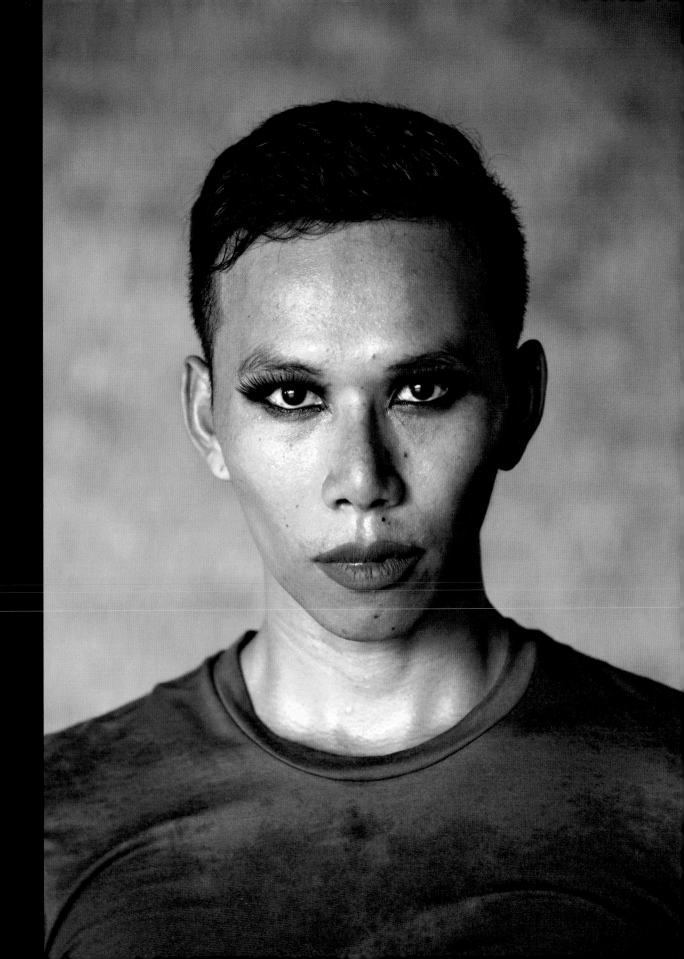

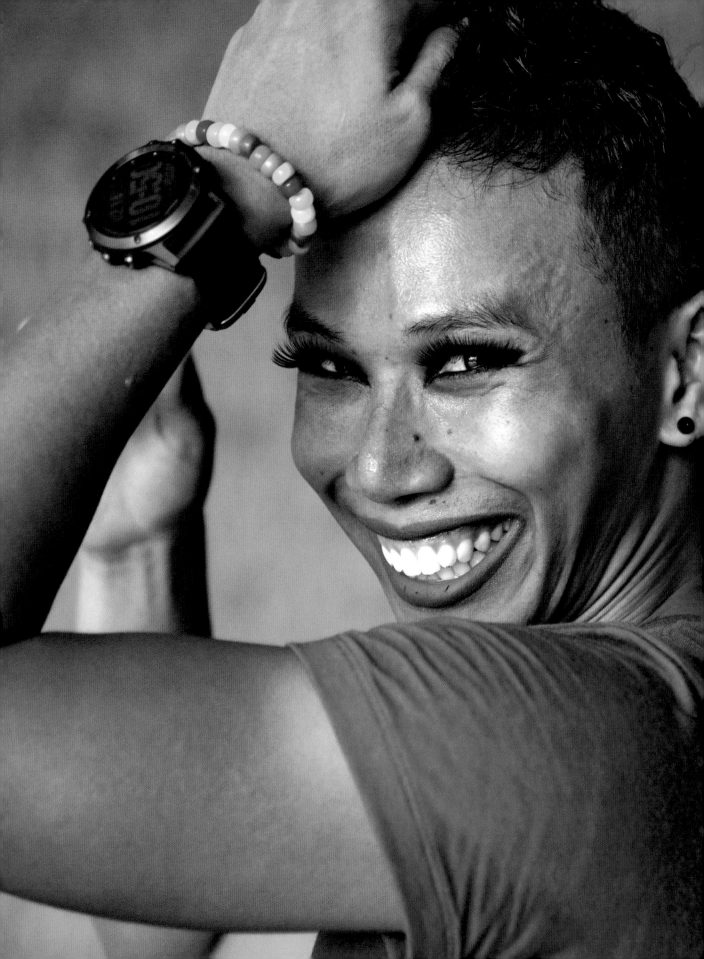

Wenika เวณิกา

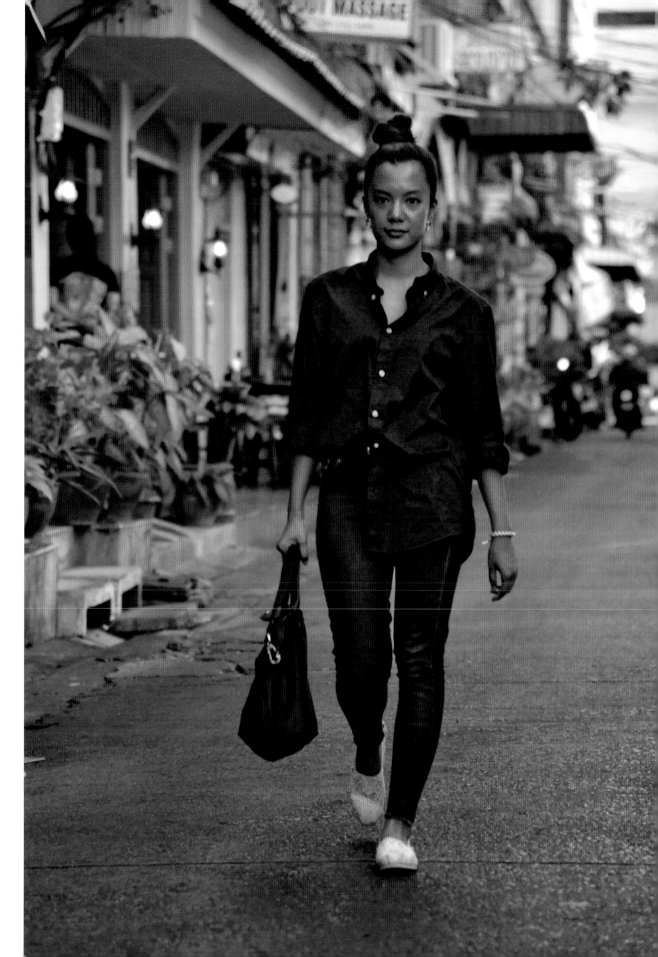

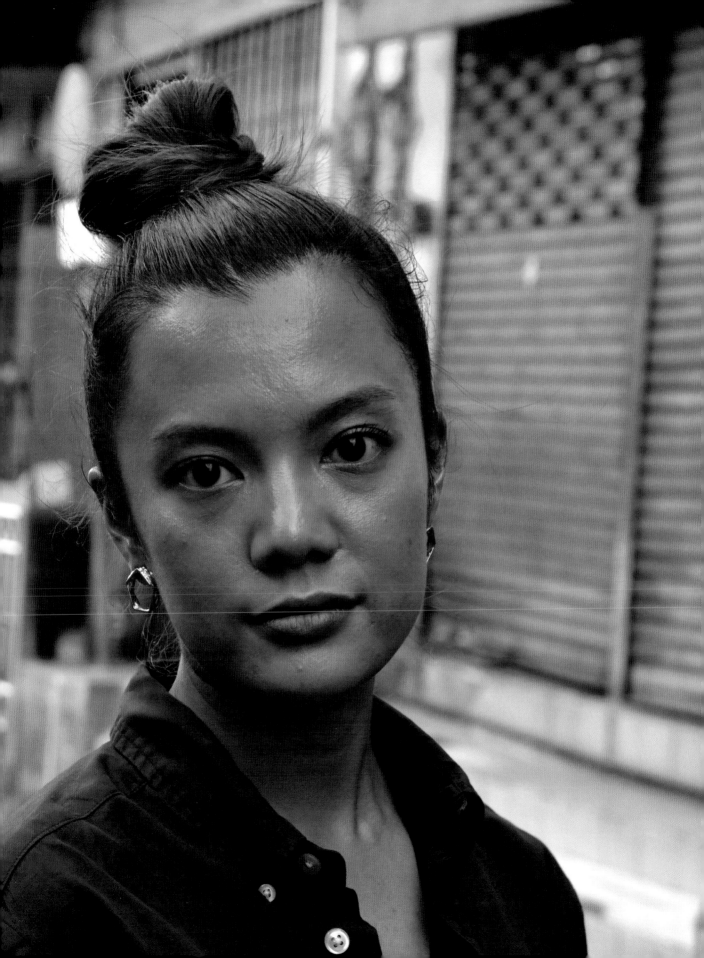

Sirichai ศิริชัย

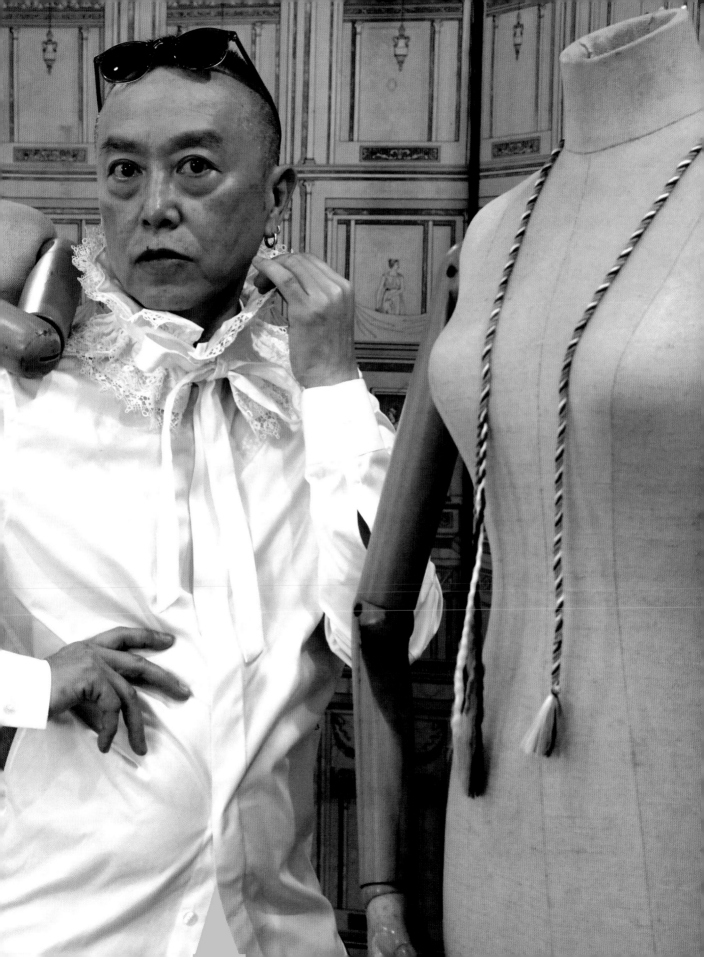

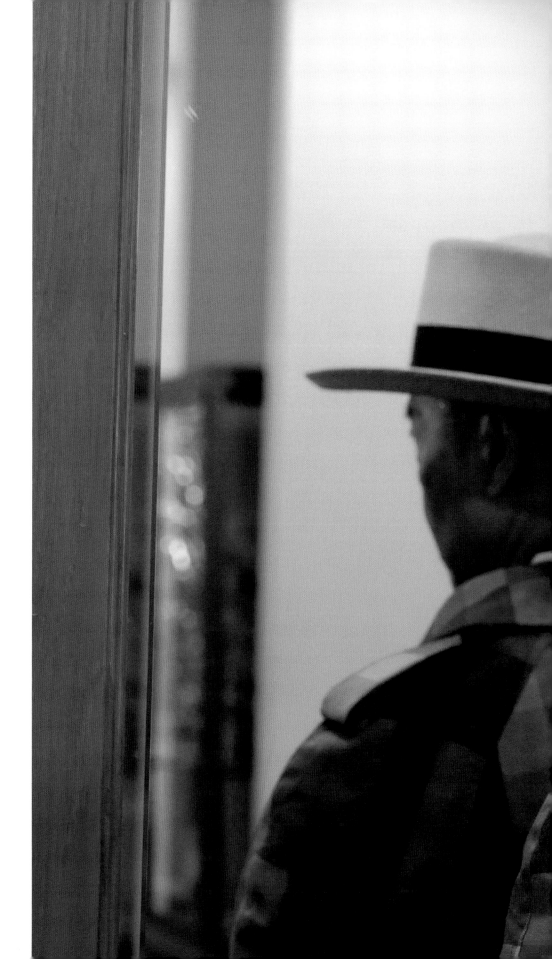

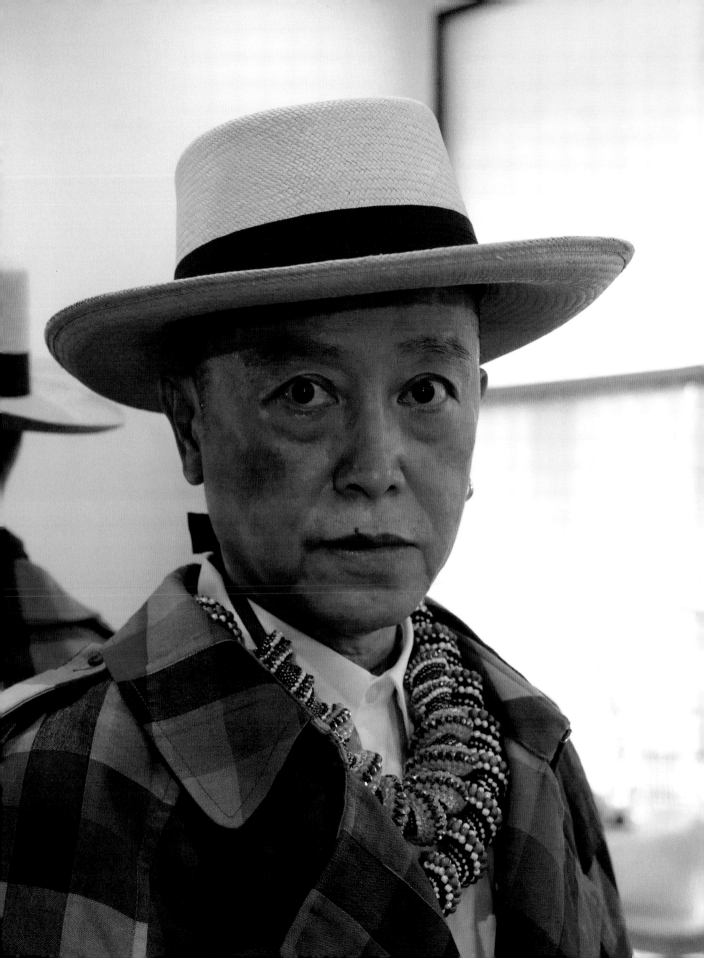

Nattika ณัฐิกา

Nawarat นวรัตน์

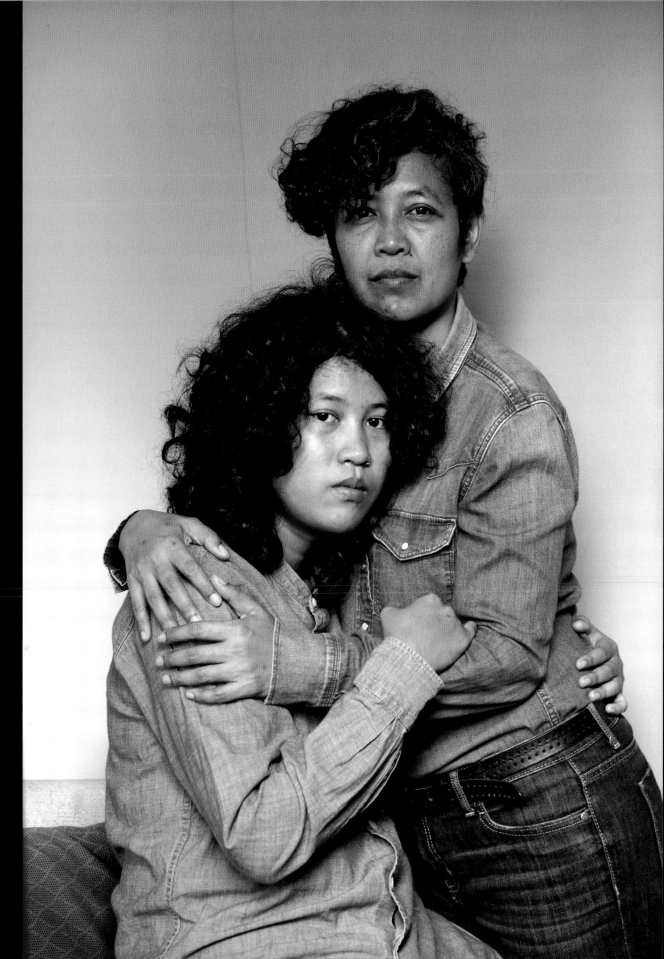

Nattika ณัฐิกา
Nawarat นวรัตน์
Nicha ณิชา

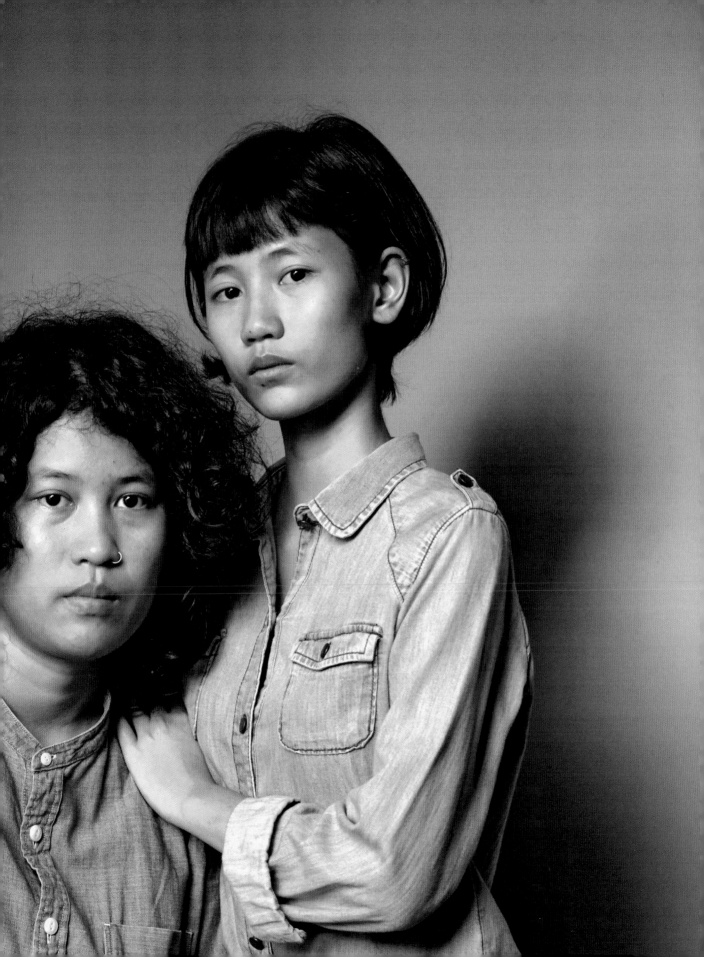

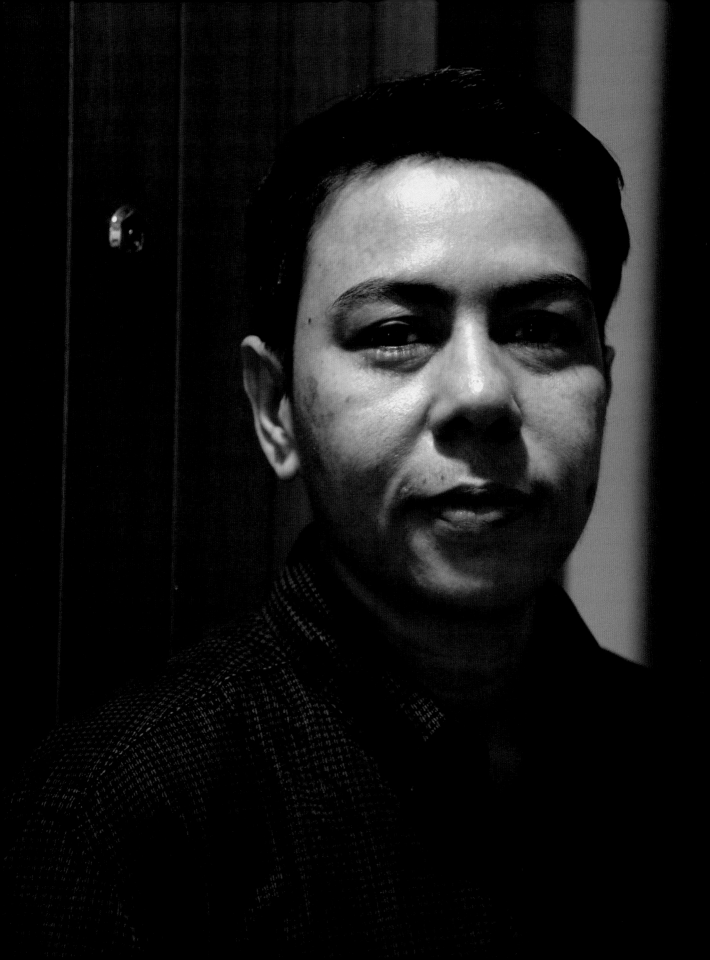

Parit พริษฐ์

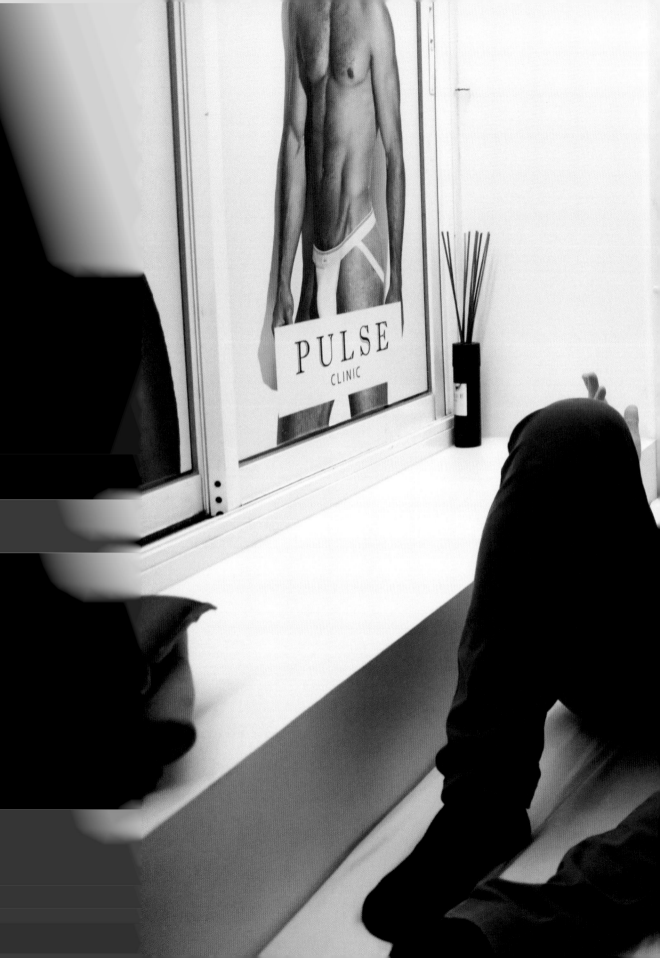

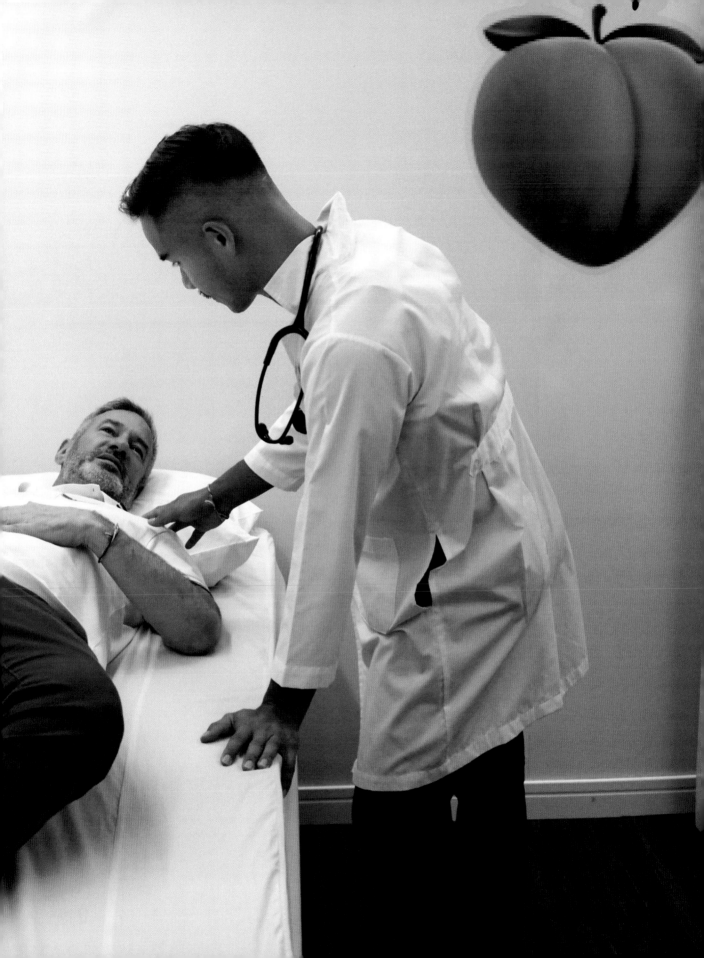

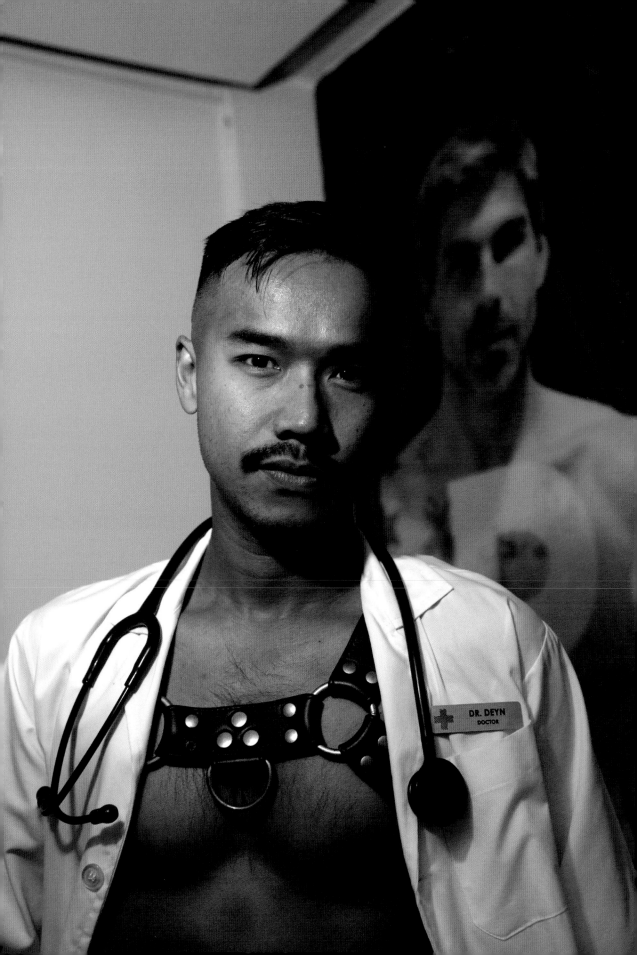

Npak ณภัค

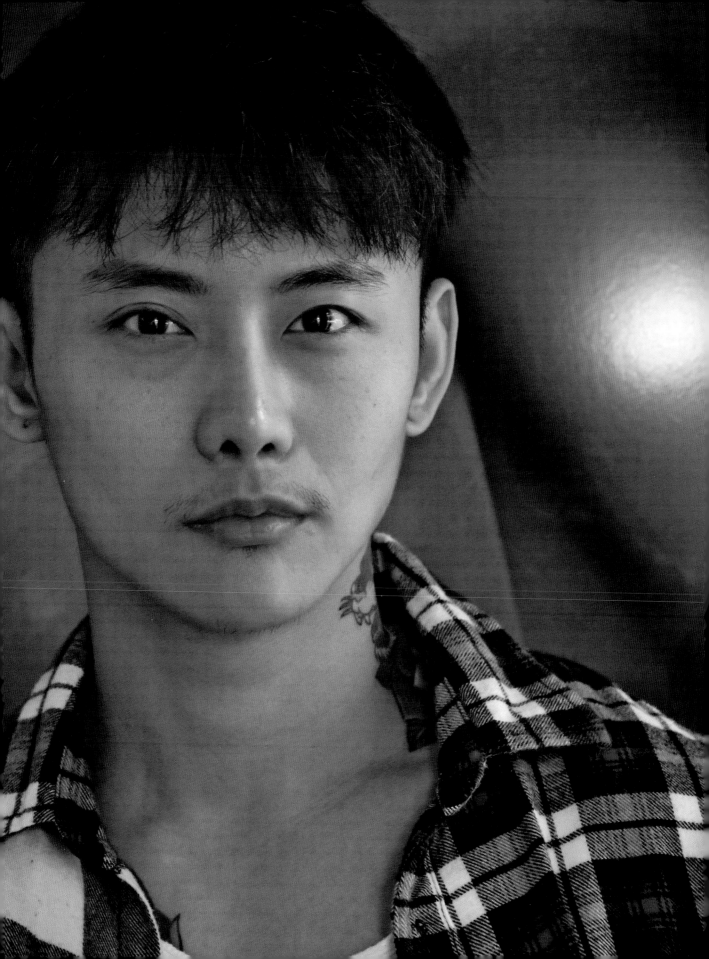

Ronnakrit รณกฤต

Yollada ยลลดา

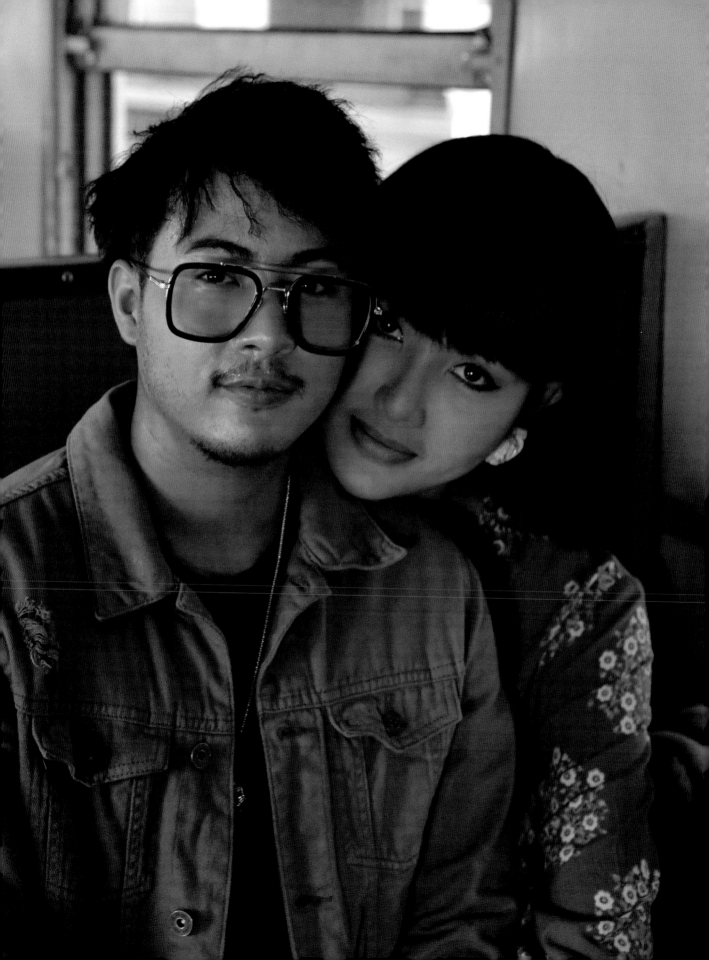

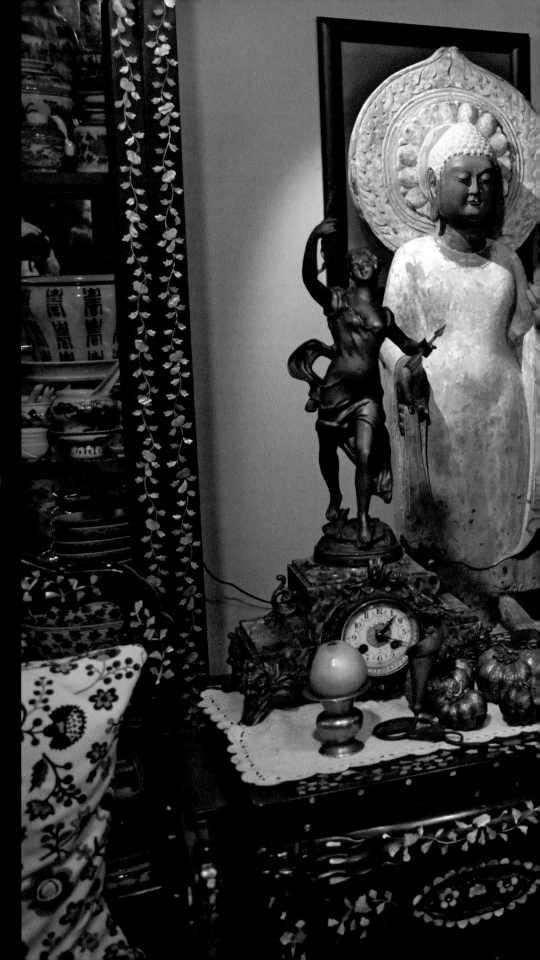

Paothong เผ่าทอง

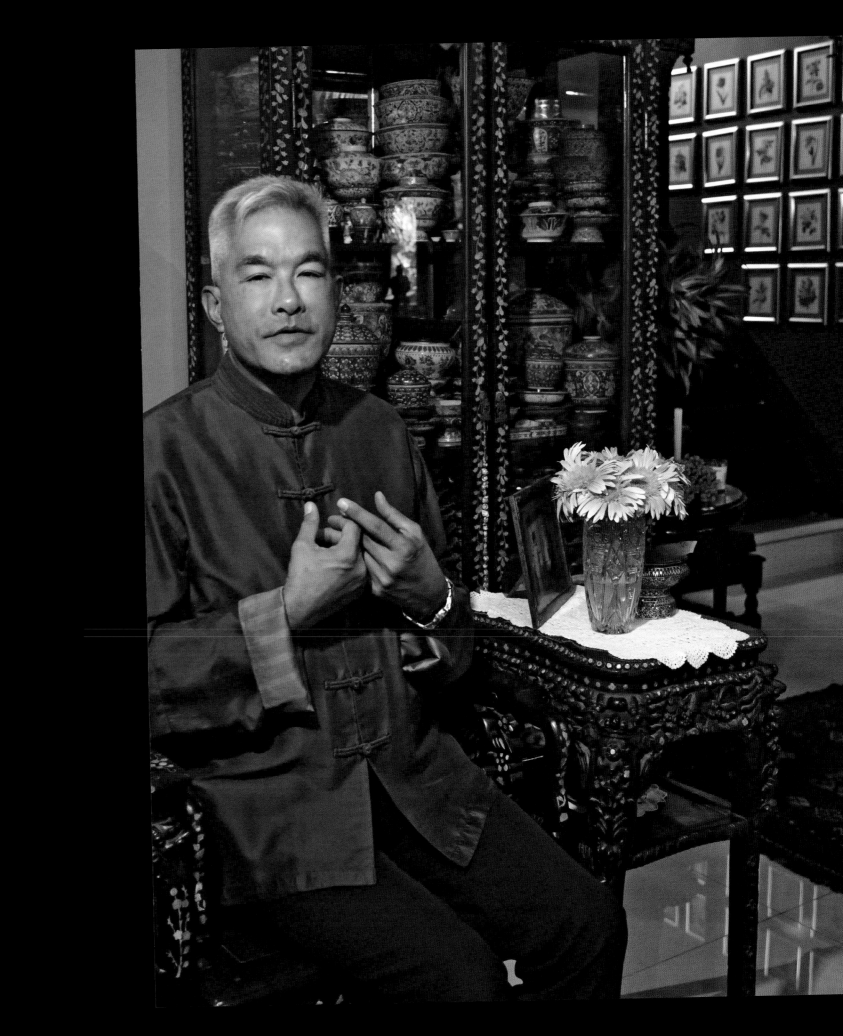

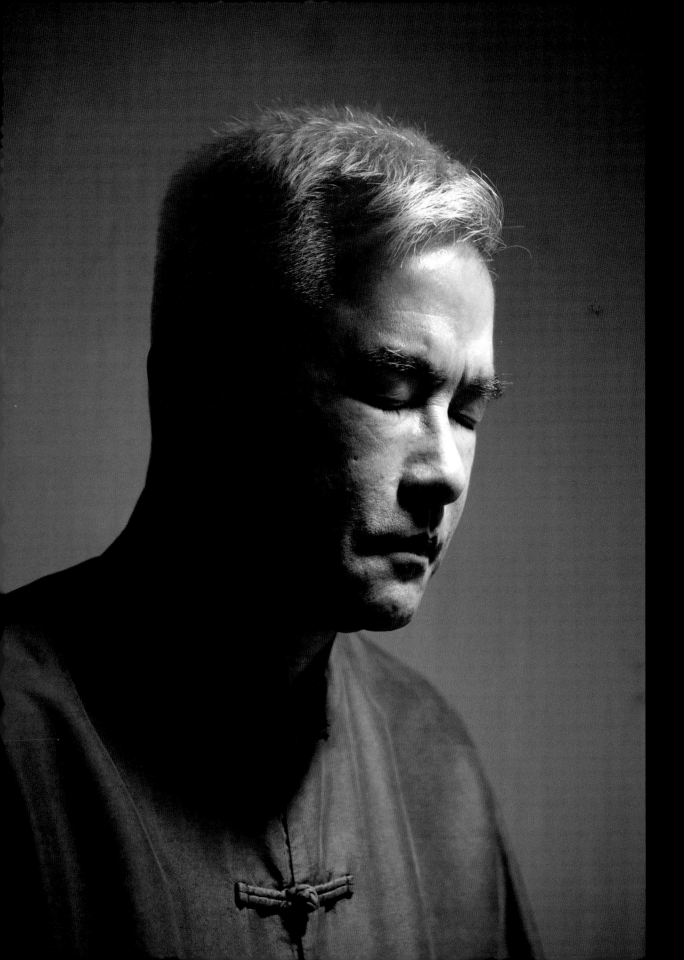

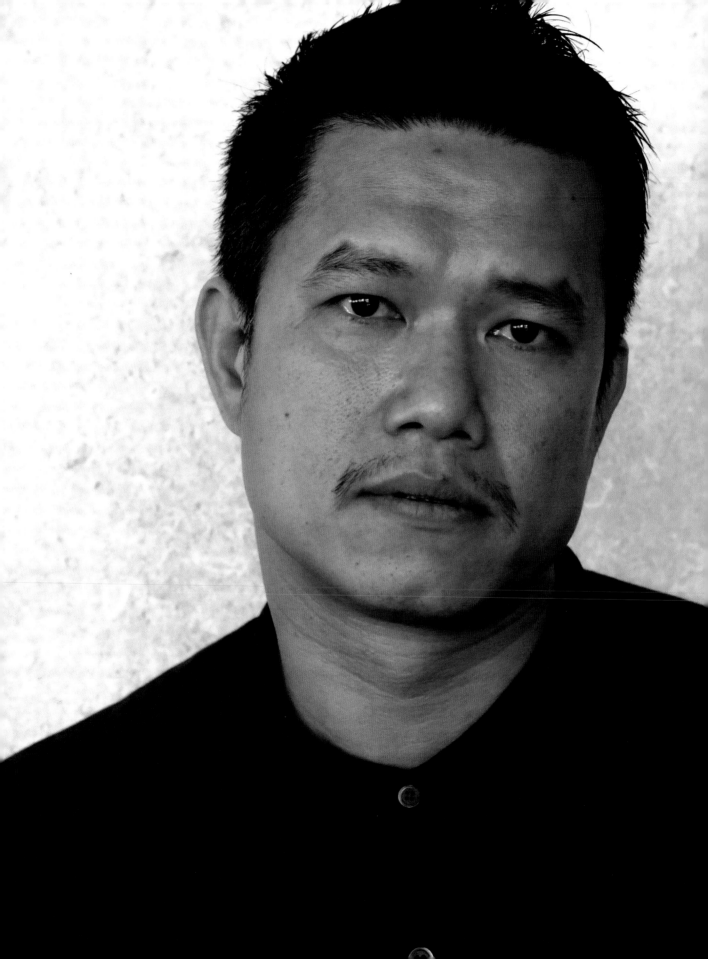

Theerawat ธีรวัฒน์

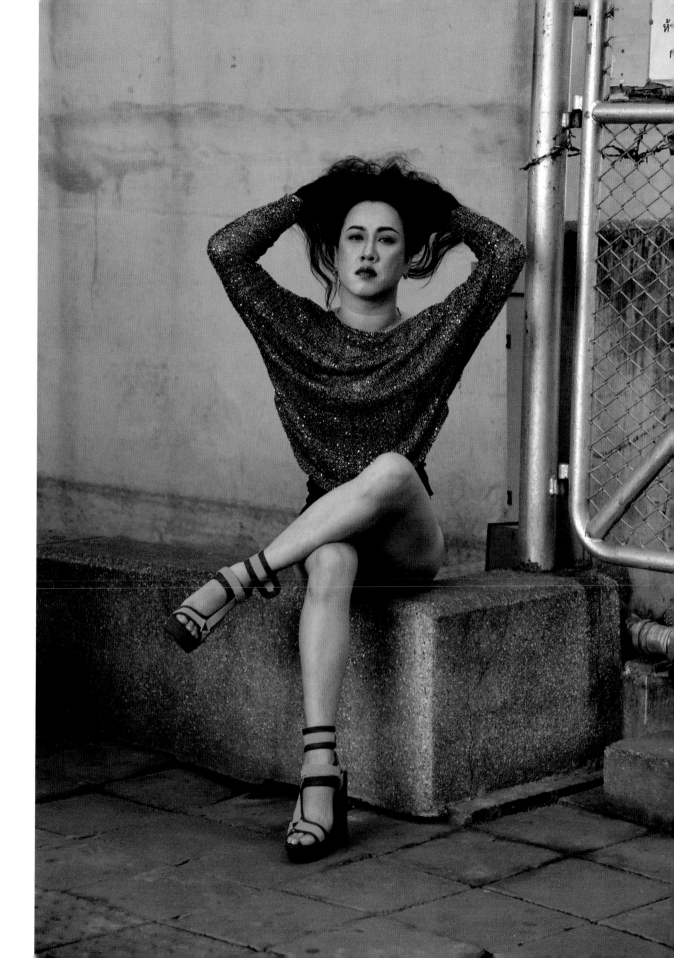

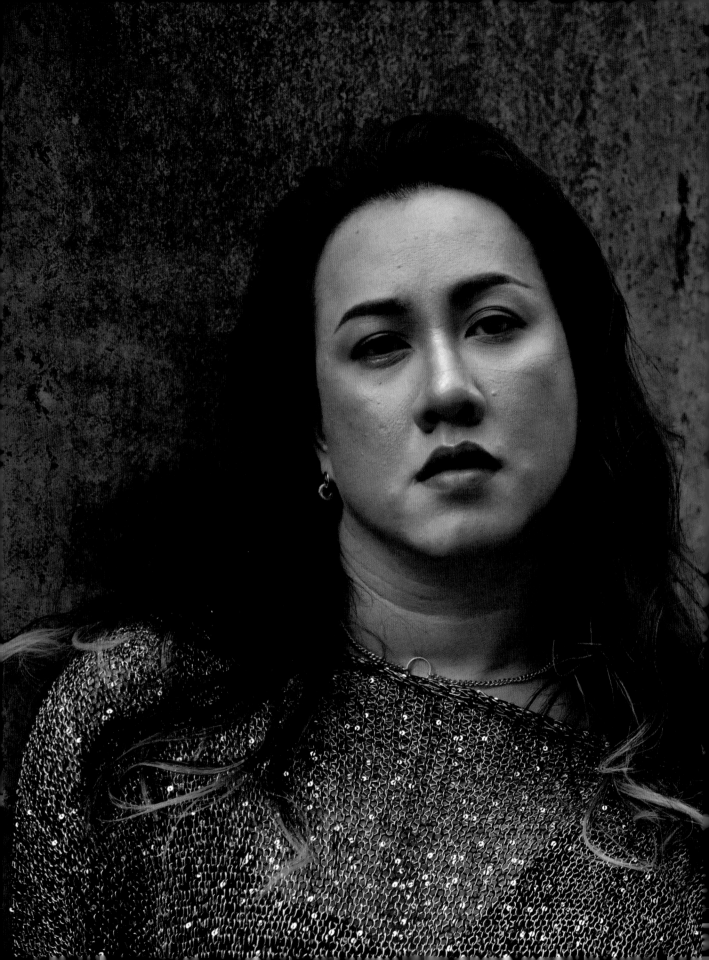

Surat สุรัตน์

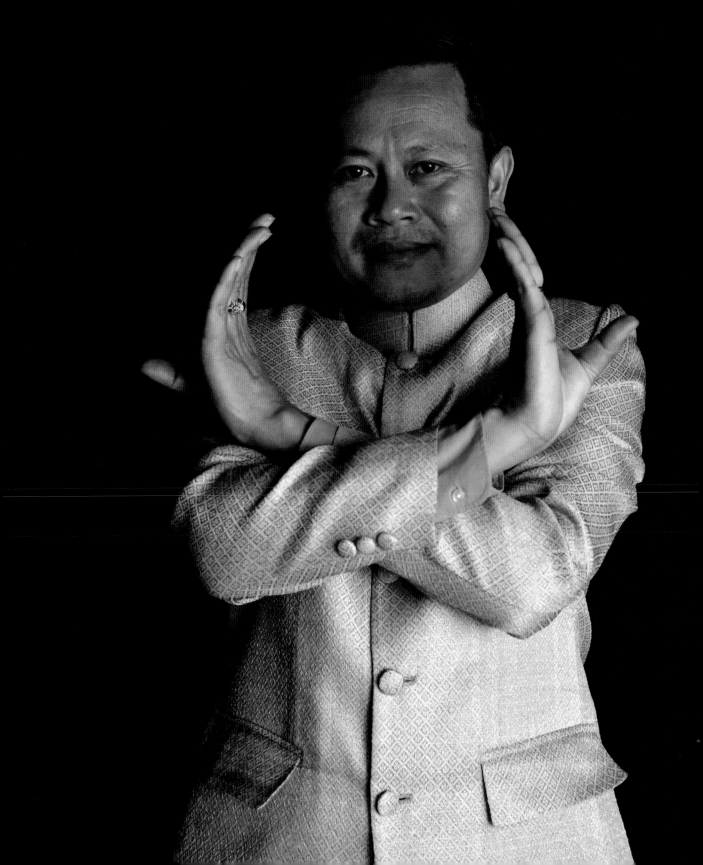

Phetcharada เพชรดา

Waleerat วลีรัตน์

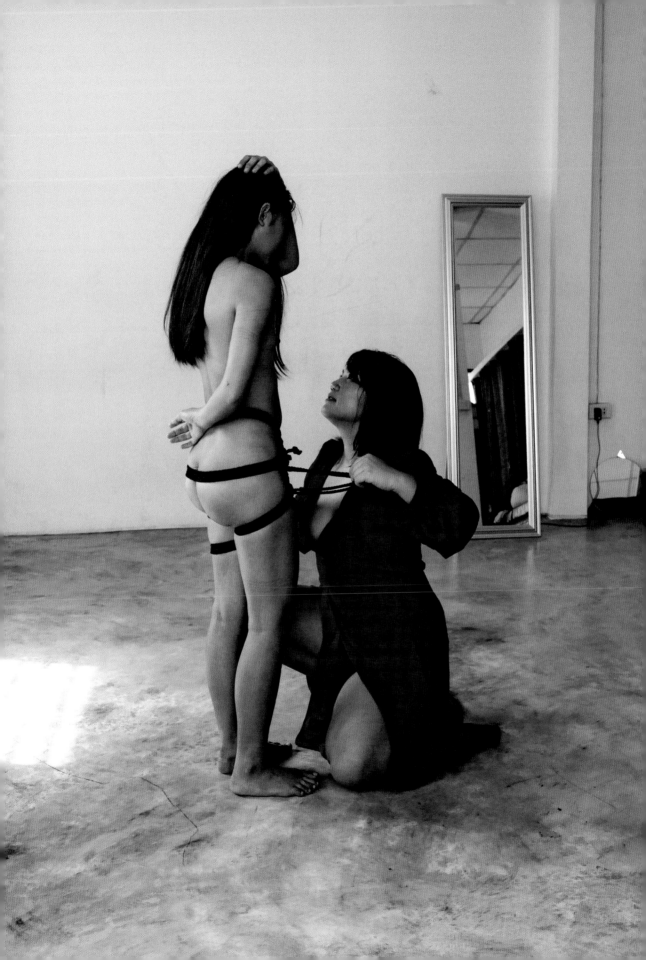

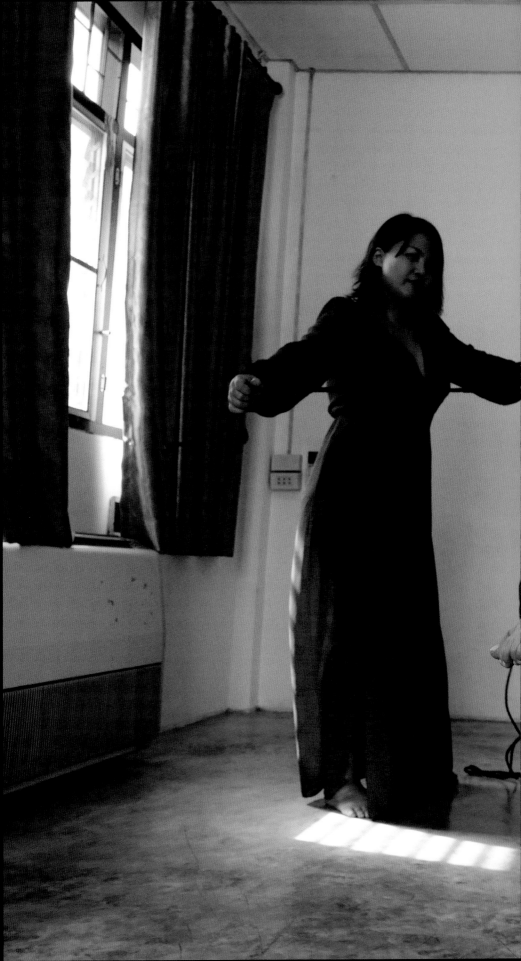

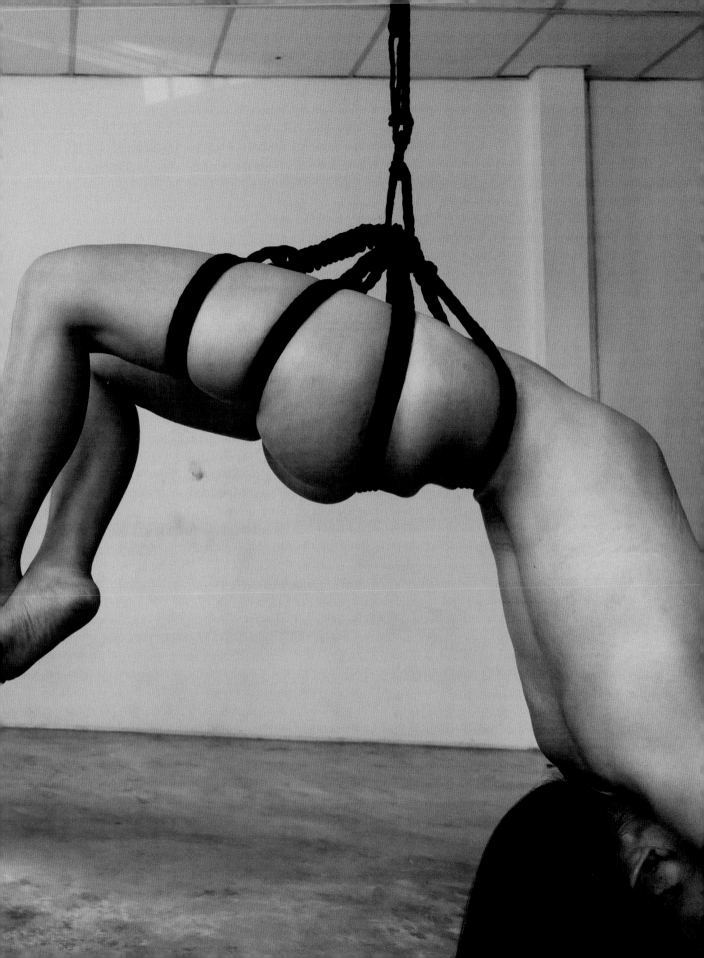

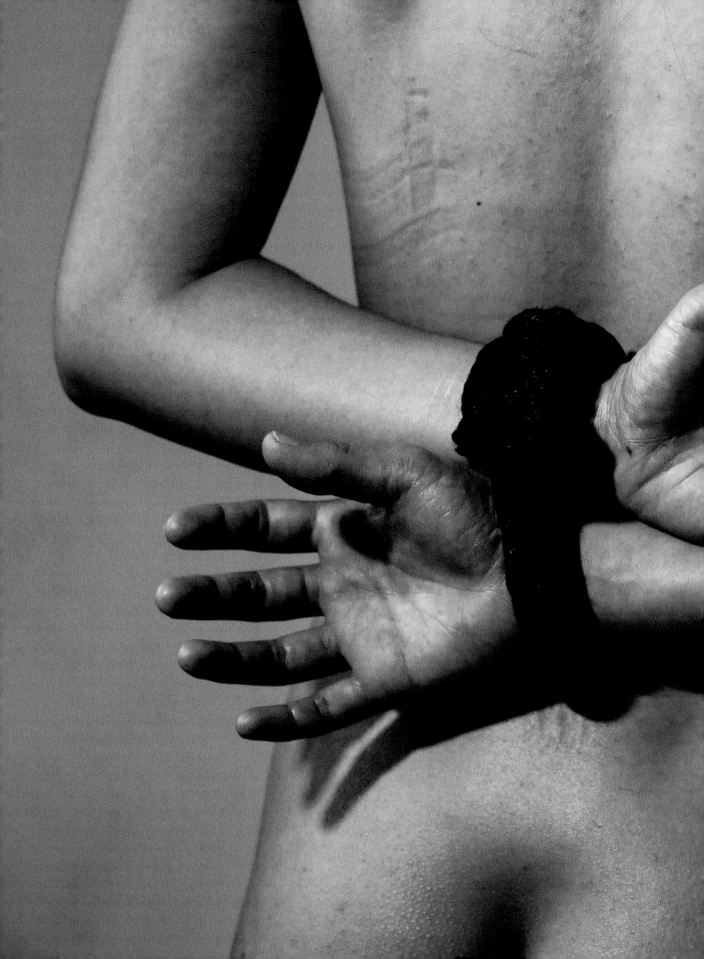

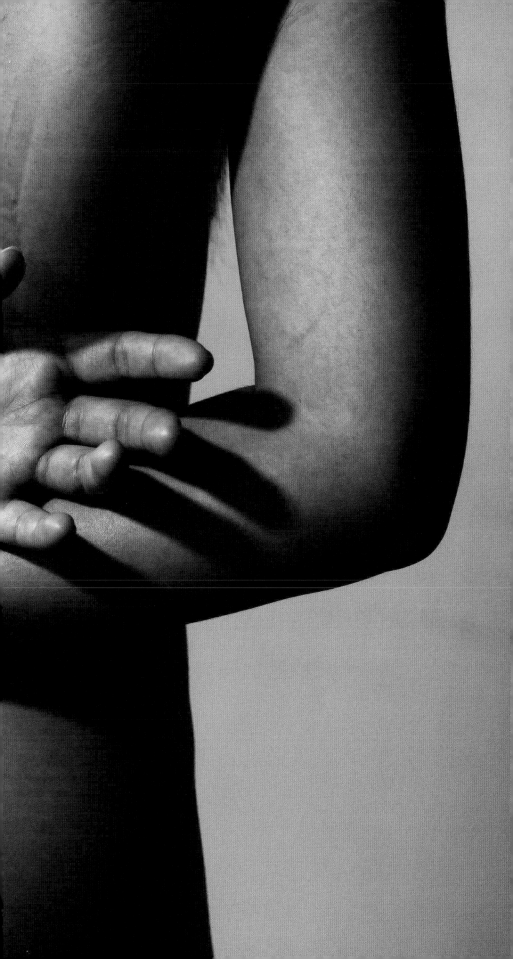

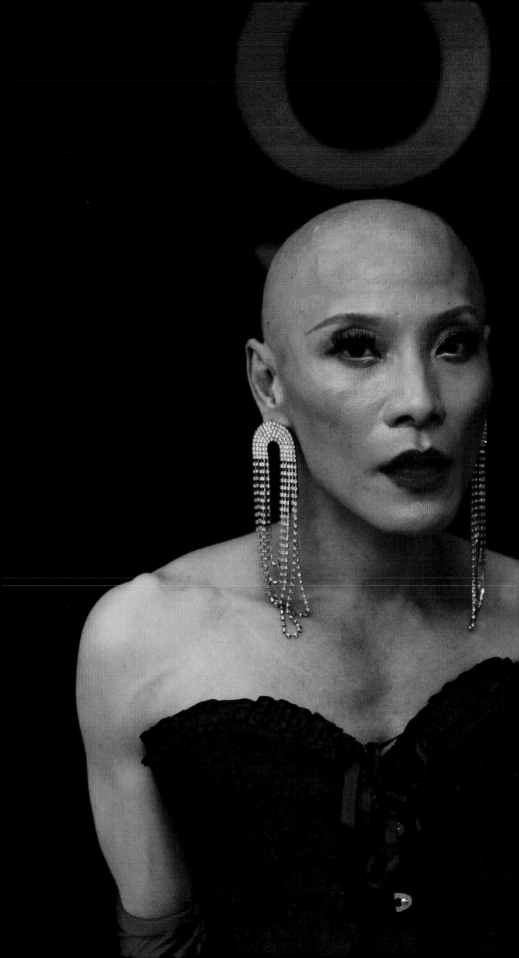

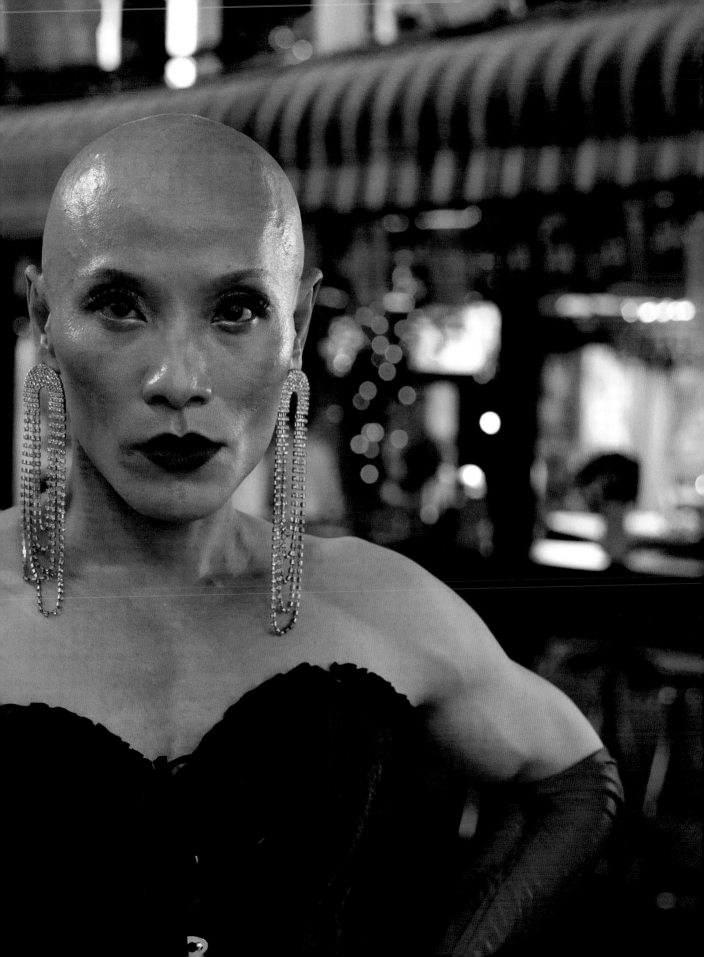

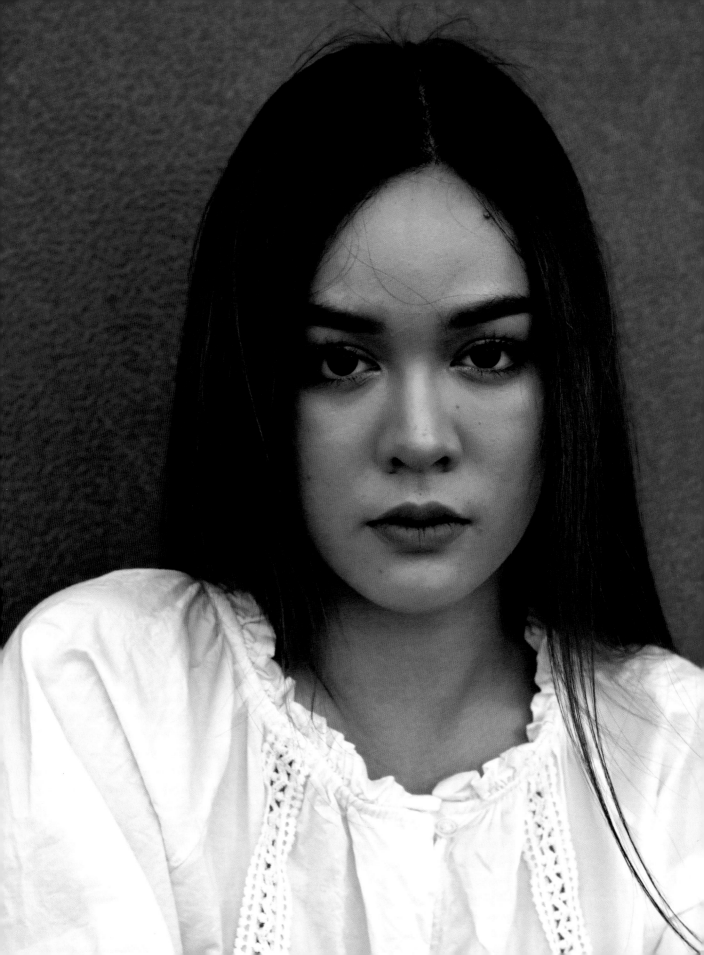

Worawalun
วรวลัญช์

Sumet สุเมธ

Tom T. ทอม

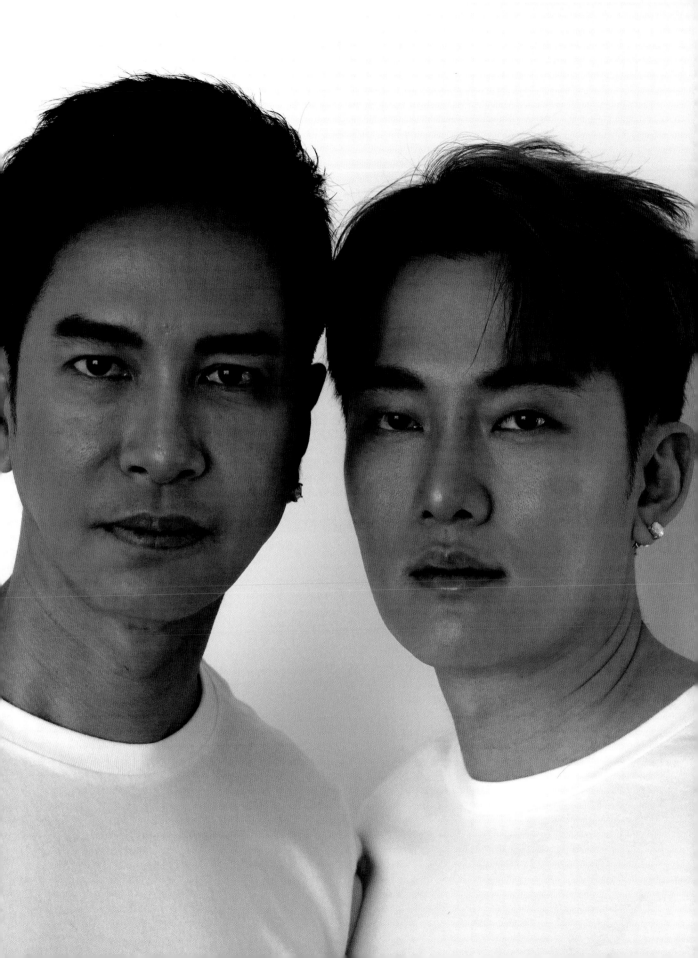

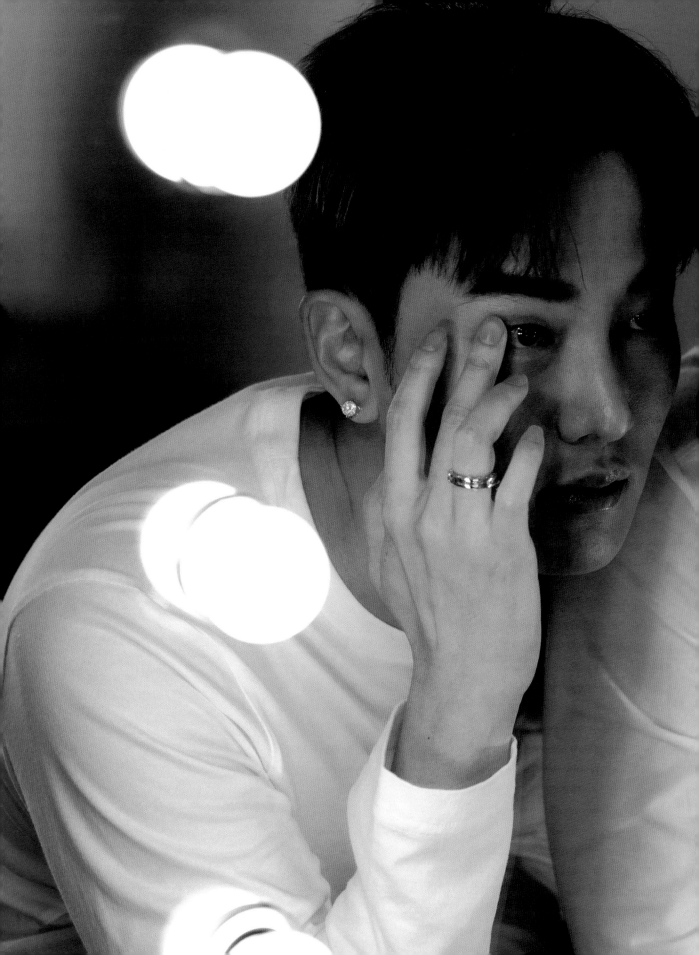

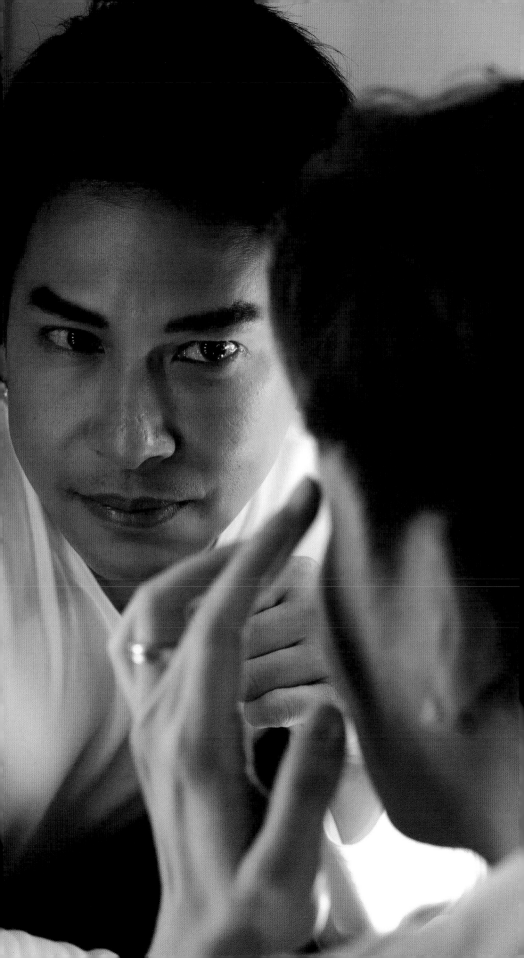

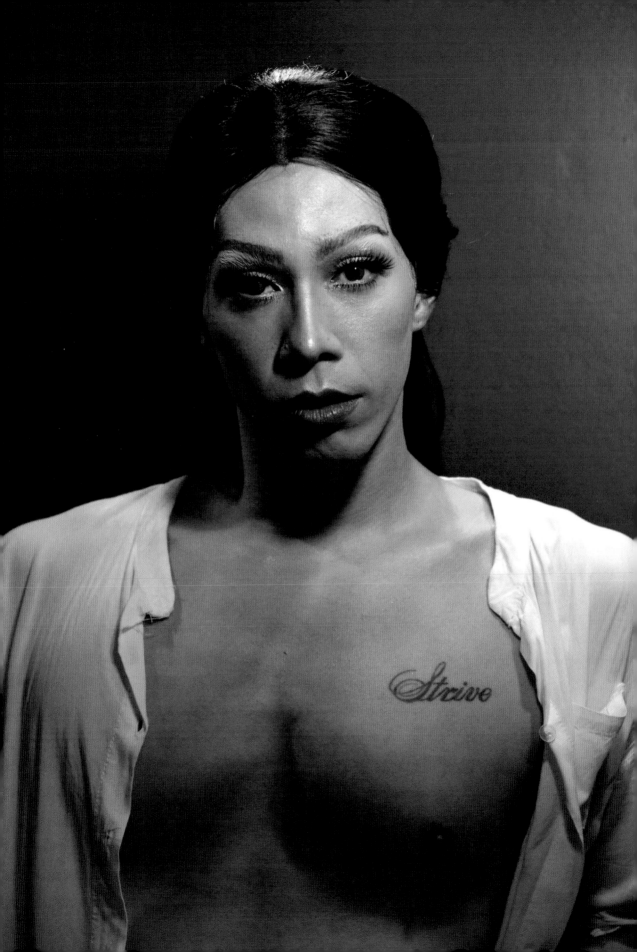

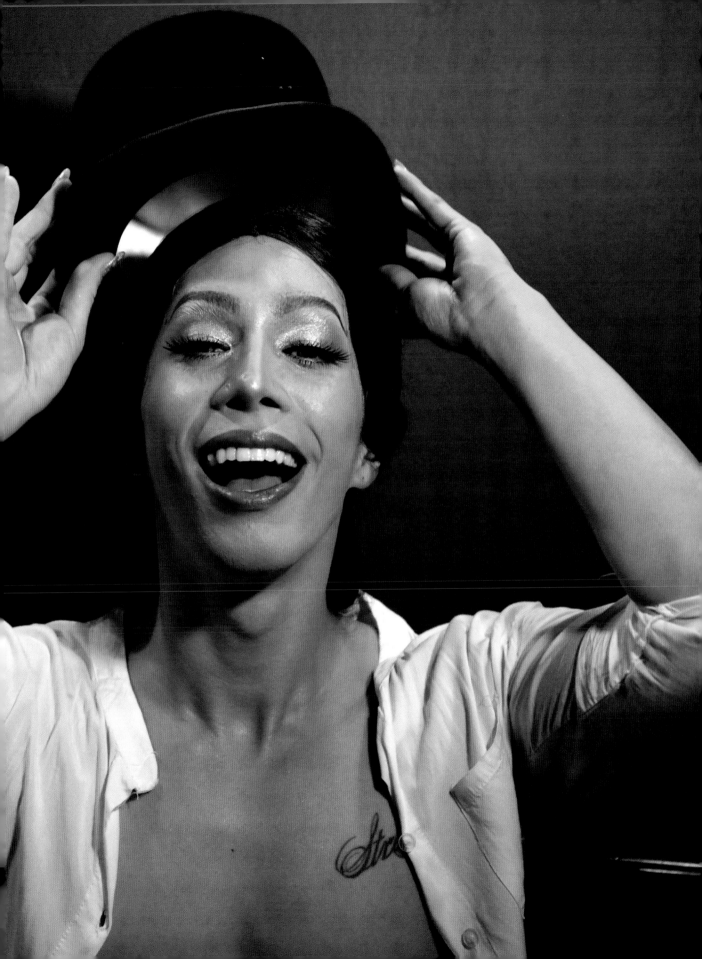

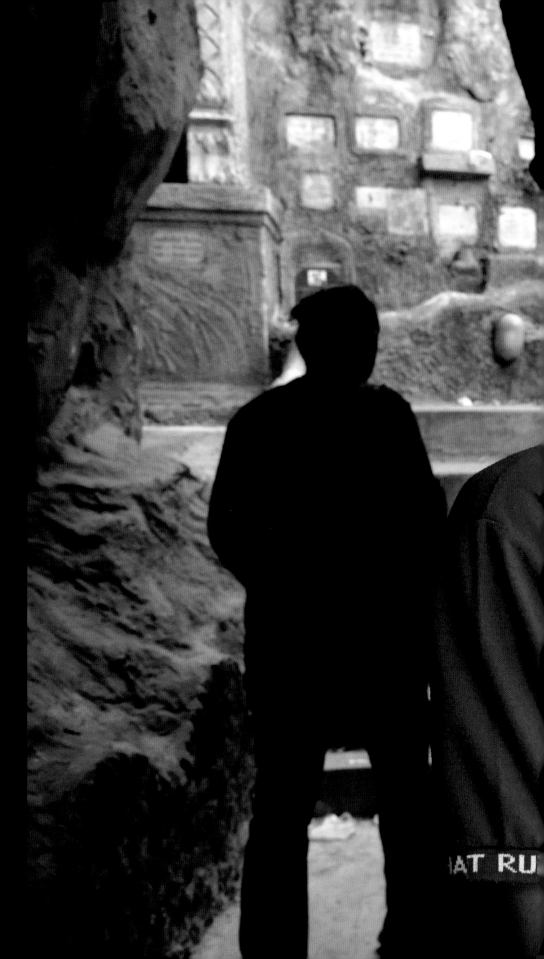

Sarawut
ศราวุธ

Benjawan
เบญจวรรณ

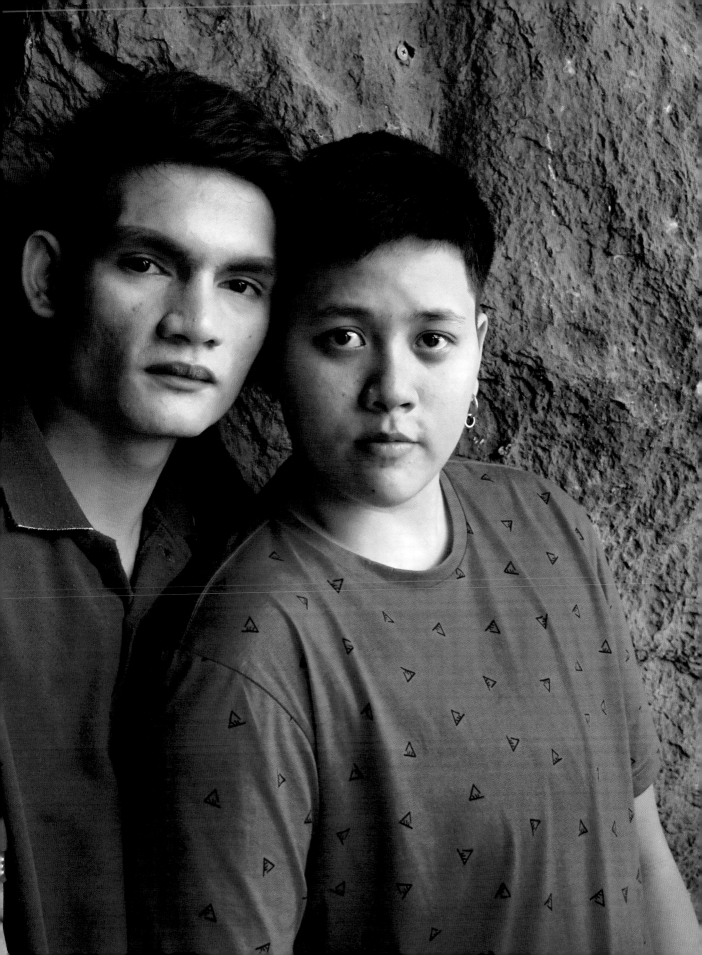

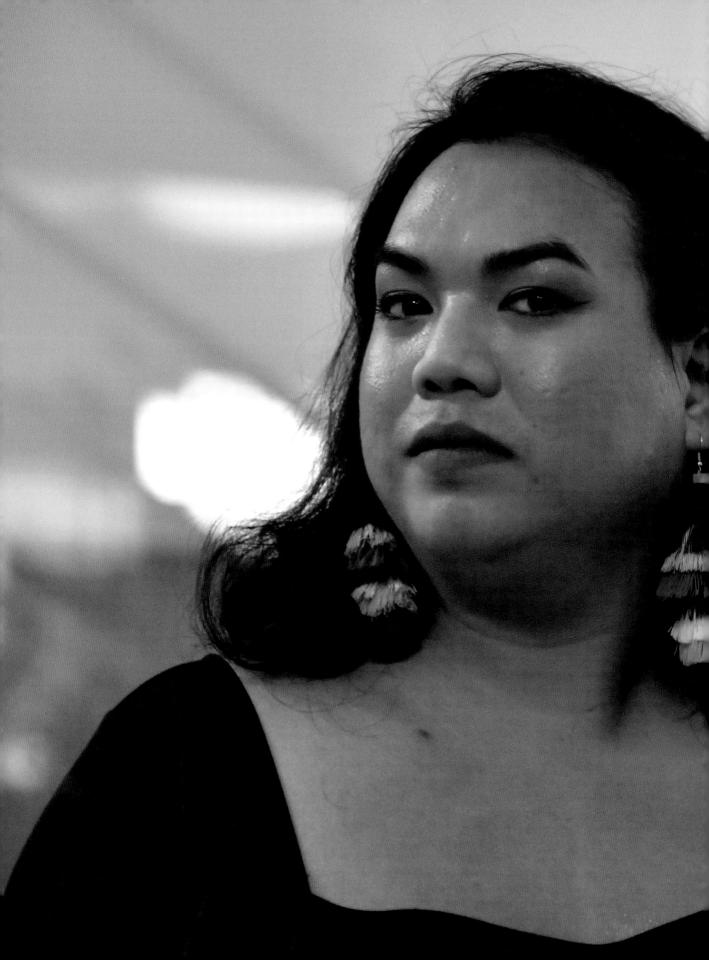

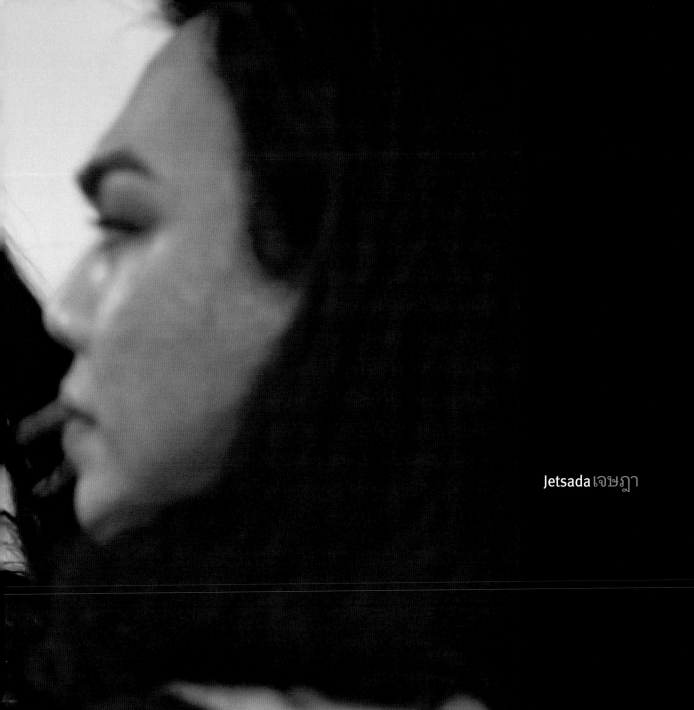

Jetsada เจษฎา

Naphat K. ณภัทร

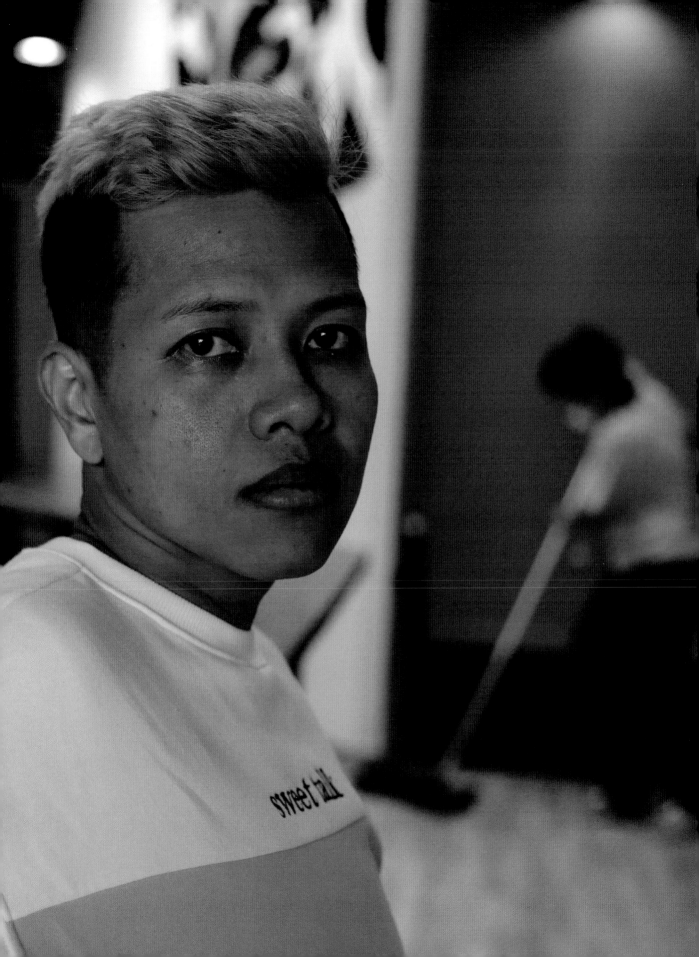

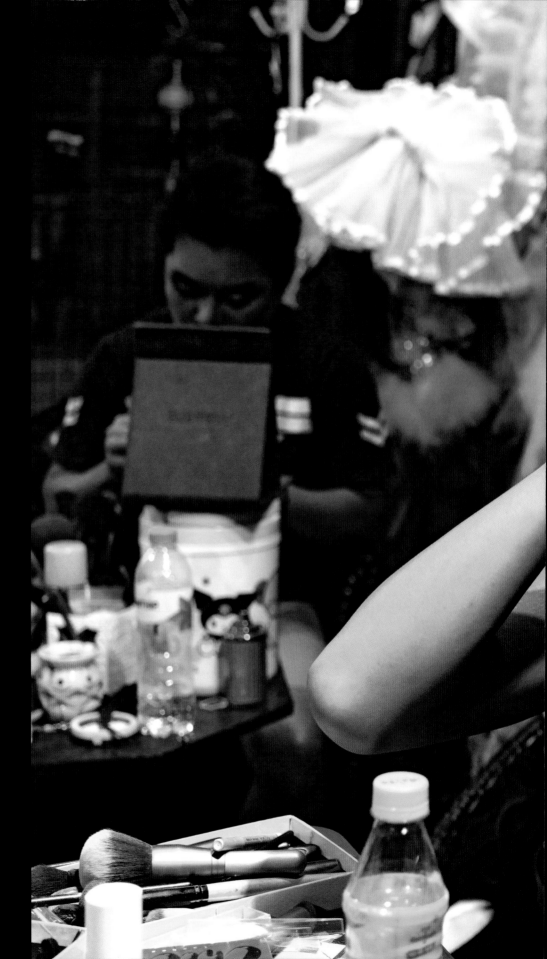

Angele อัญชลี

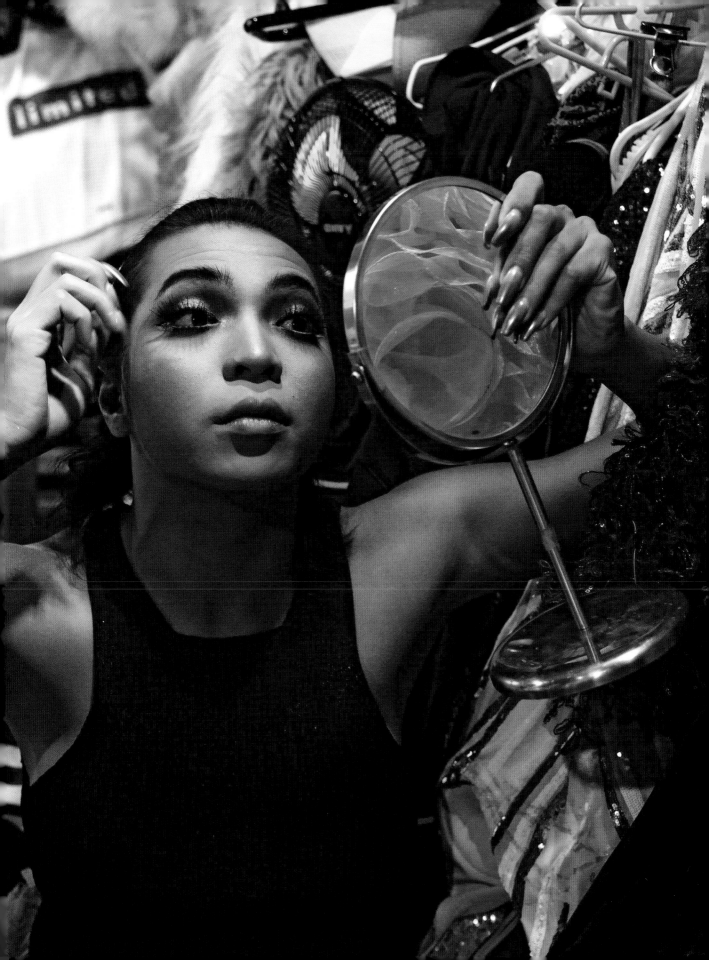

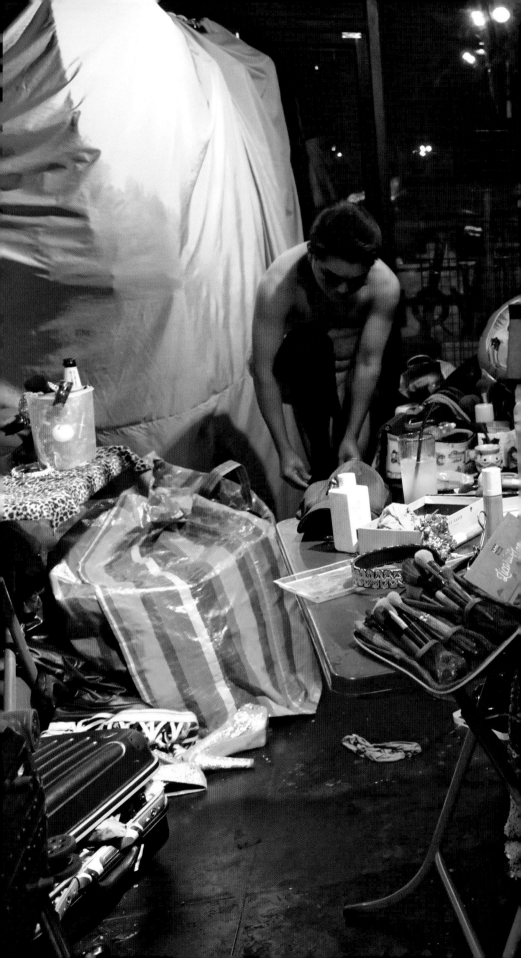

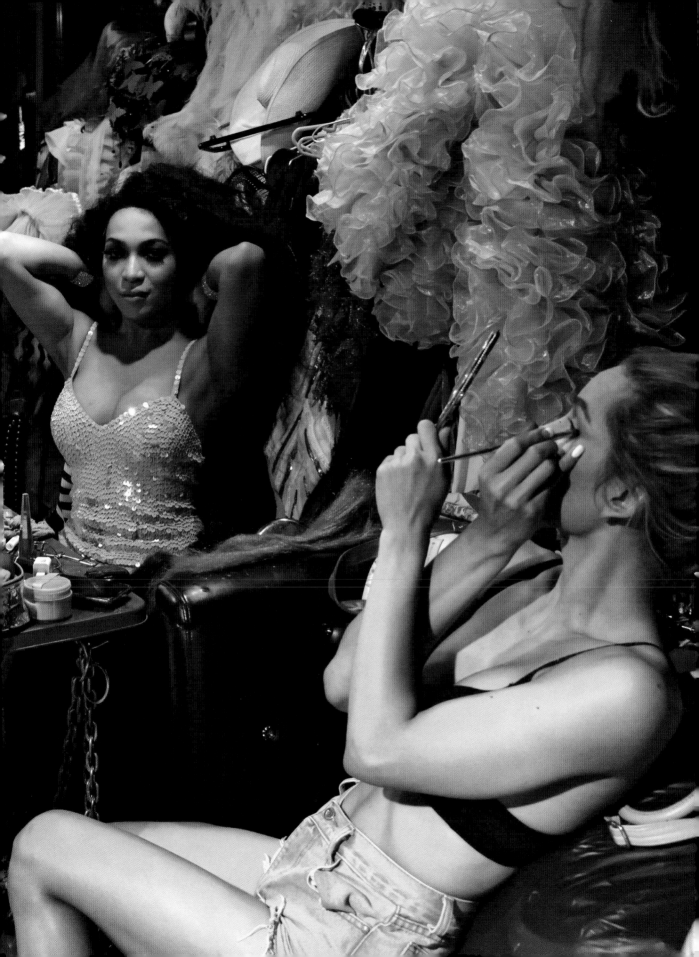

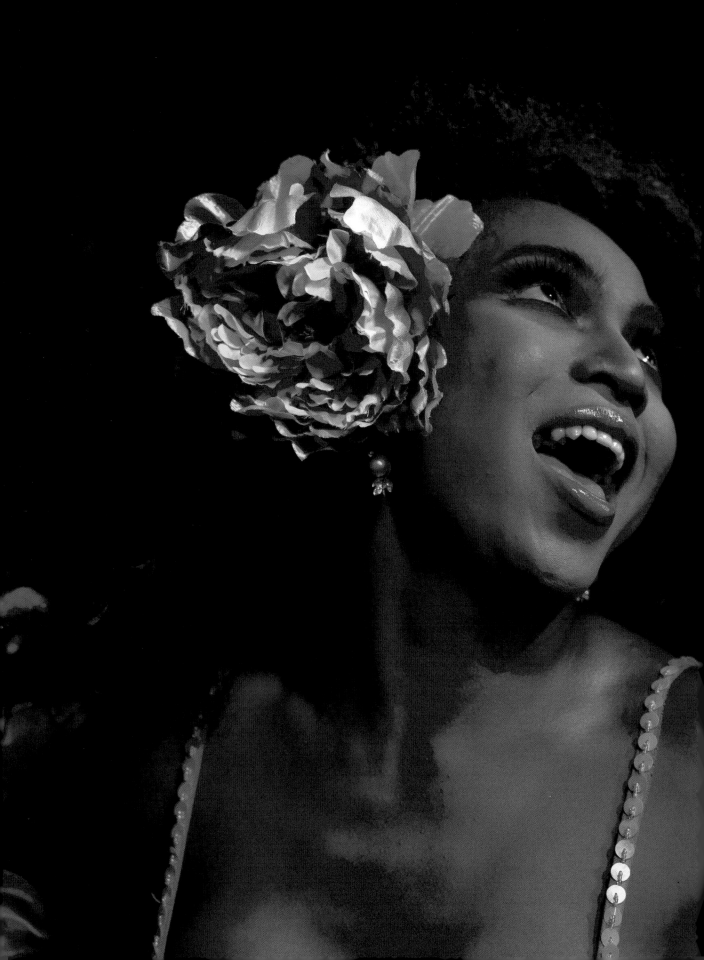

Acknowledgments

The photographs presented in this book were made possible by a commission from Jon Stryker: philanthropist, architect, and photography devotee.

This book was made possible in part by a grant from the arcus* FOUNDATION

We would like to extend our deepest gratitude to Arayaissaree Akuchugorn, Angele Anang, Boonjira Angsumalee, Apichet Atilattana, Thomas B. Van Blarcom, Dechanan Boonpalah, Nattika Boonsatitya, Nawarat Boonsatitya, Nicha Boonsatitya, Poomjai Burusupat, Sirisak Chaited, Benjawan Chatboontarix, Parit Chomchuen, Kris Chotidhanitsakul, Jatupong Chumjam, Gerard A. Clancy, Sirichai Daharanont, Kittinun Daramadhaj, Geoffrey Scott Thomas Flaxman, Ronnakrit Hamichart, Sarawut Hongmala, Panatda Hongrikul, Surat Jongda, Jirayu Juntarawong, Paradorn Katerat, Nantachet Keswiriyakan, Assadayut Khunviseadpong, Naphat Krutthai, Rojjanaruch Kunkaew, Jitsak Lim-Pakornkul, Waleerat Lomkom, Npak Maha-Udomporn, Kongyos Manonom, Pat Mayara, Pan Pan Narkprasert, Nitinan Ngamchaipisit, Pauline Ngarmpring, Chitsanupong Nithiwana, Usa Nuchyimyong, Phetcharada Pacharee, Sutichai Pangsriraksa, Naphat Panthukumphol, Sornchai Phongsa, Tom Potisit, Areerut Prasomsin, Cedric Rousseaux, Pichai R., Michael Shaowanasai, Theerayut Somtua, Sumet Srimuang, Yollada Krerkkong Suanyot, Anjana Suvarnananda, Jetsada Taesombat, Watcharin Tameesio, Tom S.G. Tan, Worawalun Taweekarn, Paothong Thongchua, Theerawat Thongmitr, Khemngern Tonsakulrungruang, Wenika Wichaiwatthana, and Dr. Natthakhet Yaemim.

*The Arcus Foundation is a global foundation dedicated to the idea that people can live in harmony with one another and the natural world. The Foundation works to advance respect for diversity among peoples and in nature (www.ArcusFoundation.org).